GWENT
INDUSTRIAL
HERITAGE

CHRIS BARBER

AMBERLEY

'The epochal industrial revolution of the eighteenth and nineteenth centuries, which changed the planet for ever, was largely fuelled by the minerals embedded in the hills of southern Wales, and for a few decades the little nation was one of the most exciting places on earth.'

Jan Morris, 2000

Recommended Maps
OS Landranger 161, 162 and 171, OS Explorer OL13, OL14 and 152

First published 2023

Amberley Publishing
The Hill, Stroud,
Gloucestershire, GL5 4EP

www.amberley-books.com

ISBN: 978 1 3981 0872 1 (print)
ISBN: 978 1 3981 0873 8 (ebook)

British Library Cataloguing in Publication Data.
A catalogue record for this book is available from the British Library.

Typeset in 10pt on 13pt Celeste.
Typesetting by SJmagic DESIGN SERVICES, India.
Printed in the UK.

Contents

Introduction

Before the Industrial Revolution, Gwent was a pastoral and agricultural area, mainly peopled with farming folk, but the western valleys were destined to become one of the most important iron-producing locations in the world.

In around 1570, several small ironworks were established at Pontypool, Monkswood and Abercarn. They relied on charcoal to fuel the blast furnaces, while fast-flowing rivers were essential for powering the bellows, and also the big hammers in the forges. This meant that the ideal site for such works was beside a suitable river with large woodland nearby. Ironstone was obtained mostly by scouring and leaching, but fortunately limestone, the other essential ingredient for ironmaking, was plentiful on the slopes of the northern hills of the western valleys.

An important change came in 1709, when Abraham Darby of Coalbrookdale in Shropshire discovered that once sulphur was removed from coal it could be used in the form of coke, which proved a better fuel for smelting. In due course, as coke was generally adopted as a fuel, the iron industry rapidly went into a new stage of development.

Between 1760 and 1840, a chain of ironworks was established along a narrow strip of hill country stretching for about 20 miles between Blaenavon and Hirwaun. Situated in narrow valleys and separated from each other by the intervening ridges, these ironworks were close to rich deposits of ironstone, coal and limestone. This mineral wealth was ruthlessly exploited to make Gwent and Glamorgan the most important ironmaking region in Britain.

In the early days of this industry the only form of transport between the ironworks and the coastal ports was the packhorse, which meant that there was an urgent need for good communications. This resulted in the construction of canals, tramroads and eventually railways.

People seeking work came in their thousands from the rural parts of Wales, England and Ireland, attracted by the possibility of employment and higher wages than they could receive as agricultural workers. This growth in population resulted in overcrowded and insanitary living conditions, which caused disease in the rapidly developing towns. In particular there were several outbreaks of cholera in some communities, where people lived in ever-increasing squalor. Rivers that once sparkled with clean water and were

alive with trout became little more than open sewers. Rotting garbage tips and backyard piggeries also gave rise to contaminated water supplies.

It seems hard to believe now, but children as young as five worked alongside their parents at the mines and ironworks. These youngsters might sit for twelve hours in the dark, opening and closing air doors at the approach of horses and trams moving to and from the coalface.

Rees Jones, aged thirteen, described his working life as follows: 'I am a haulier and drive a horse and tram in the mine levels; I have been at work for five years and at first I kept a door. I go out with the horse about six or seven o' clock in the morning, and work almost twelve hours every day. My father has five children. There are two girls besides me working, one is sixteen, the other twelve years old, one is with father and the other keeps an air door.'

It was not until 1860 that heavy fines were introduced in order to eliminate the possibility of women and children working underground and this had the desired effect, but it is surprising that today the law preventing women working underground was repealed on 26 February 1990.

During 1740, only 900 tons of iron were produced and the total quantity in Britain was less than 18,000 tons, but by 1846 the quantity of iron shipped from Newport Docks alone reached 220,609 tons. This large increase was due to the construction of the Monmouthshire Canal and the numerous tramroads established to Newport from Sirhowy, Nantyglo and Blaenavon.

Today, it is fascinating to study the birth of our industrial society with its associated evils of exploitation and social deprivation. However, Industrial Archaeolgy is a comparatively recent subject for it is a term that first appeared in an article by Michael Dix, published in the *Amateur Historian* in 1955.

Four years later, the Council for British Archaeology organised a National Conference to launch the subject and it embraced many aspects such as the study of the remains of early blast furnaces, tramroads and canal architecture.

For those interested in this subject, Gwent offers a wealth of fascinating sites, some of which have been preserved as our heritage, whilst others have been largely reclaimed by nature. However, even where history has blended with scenery, there is a treasure trove of fascinating places to visit, for those who come here in search of a bygone age.

This book contains just a selection of industrial sites that are of very special interest and is an attempt to provide a tribute to the people of the Industrial Revolution who laboured on windswept hillsides, constructed furnaces, tramroads and worked deep underground extracting coal and ironstone to produce iron.

Also, I have set out to record the remarkable skill of the engineers such as Isambard Kingdom Brunel who built iron bridges, stone viaducts and railways, many of which have stood the test of time and are still in use today.

Chris Barber

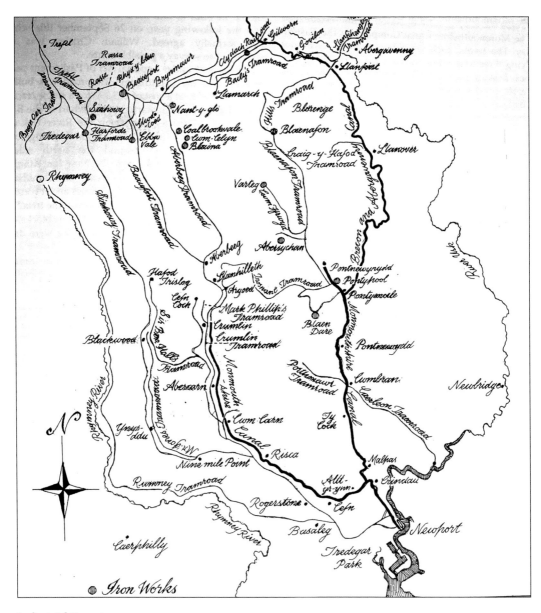

Industrial Gwent.

1

Ironmaking in the Wye Valley

If you have an interest in industrial archaeology a good starting place is Tintern in the Wye Valley, which has long been famous for the impressive ruins of its Cistercian Abbey, situated beside the River Wye in such an unspoilt location. However, surprisingly, this was once an important industrial area.

The Angidy Valley above Tintern is particularly fascinating as Britain's first wire drawing works were established there in 1566, and by the mid-eighteenth century a large complex of iron and wire works was spreading from the banks of the Wye and up this side valley for nearly 2 miles

From Pont y Saeson the fast-flowing Angidy Brook falls 300 feet to the Wye, and in this valley there are three small reservoirs, known as the Upper, Middle and Lower ponds, which were all constructed to serve a series of industrial undertakings. Records show that by 1821 there were no less than twenty-two waterwheels operating in this picturesque, wooded valley.

The story begins in 1565, when, with the sanction of Elizabeth I, William Humfrey and Christopher Schultz formed a company called the 'Governors, Assistants, and Society of Minerals and Battery Works' and looked for a suitable location to establish their business. They needed a fast-flowing river and, failing to find a suitable site in England, they crossed the Severn to investigate the Wye Valley, where they found an ideal spot at Tintern for establishing a wireworks.

Not only was the Angidy Brook suitable for driving their hammers and machinery, but charcoal could be made from the abundance of surrounding woodland, and there was also a good supply of iron ore in the locality.

Work began to set up a wireworks, and two years later wire was being sold to Bristol and Gloucester at £50 13s 4d per ton to be used mainly for making carding combs needed by clothiers.

For good quality wire they needed supplies of Osmond iron, which was a product of a special type of forge that called for high-grade ore. This was initially obtained from Monkswood, near Usk, and Pontypool. However, in due course, the Mineral and Battery Company decided to build their own furnace and forge at Tintern.

Abbey Furnace Tintern – The Last Furnace in Wales to Use Charcoal

This furnace was built to produce the special Osmond iron that was needed to make wire. It was erected against a bank so that charcoal and ore could be carried straight from a storehouse at a higher level and loaded into the top of the furnace. Water from the Angidy Brook was directed along a leat and a wooden launder to drive a waterwheel, which powered a bellows that gave a blast of air into the bottom of the furnace. It was necessary to keep the temperature at a constant 3,000 degrees Fahrenheit. Every twelve hours, molten iron was released into sand moulds in the casting house where it cooled to form cast iron.

When in full operation the weekly output was about 30 tons of pig iron, with the furnace consuming forty-dozen sacks of charcoal, each one containing twelve bushels. Thus, sixteen sacks of charcoal were consumed to make 1 ton of pigs.

The works changed hands several times and an important modification was made when it was leased to David Tanner of Monmouth. In 1760, the original bellows was replaced by a set of blowing cylinders – the first charcoal furnace in Britain to operate in this way.

Tanner employed a workforce of 1,500 men and operated this works for twenty-four years, but then went bankrupt. It changed hands several times, but ultimately shut down in 1828. This was inevitable, as coal was now being widely used for smelting and there was no convenient coal mine available.

The wireworks were operated for another twenty-four years, and in 1872, when the Wye Valley Railway was being planned, a decision was made to build a branch line to the

Remains of the Angidy Ironworks, built in 1550 on the southern bank of the Angidy river. It was in operation for around 220 years. The pit, which contained a 24-foot-diameter overshot waterwheel, can be seen in the foreground. Water was conveyed to it on a wooden lauder.

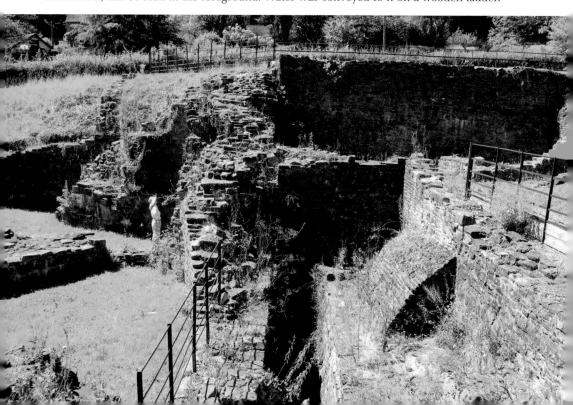

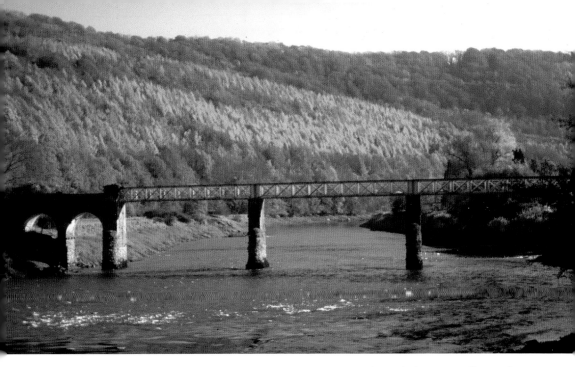

Bridge built across the Wye in 1876 to link the Lower Wireworks with the Wye Valley Railway.

wireworks. It involved the construction of an iron girder bridge over the river, and when the line opened in 1876 it was hoped that this improvement in transport would help to increase trade at the wireworks.

In 1880, J. Griffiths & Co. took over the lower wireworks and 300 men were employed there. It ceased operating in 1895 and was taken over by the Abbey Tinplate Co., which closed down in 1901 and the plant was sold for £1,500.

It seems hard to believe now that Tintern was once an industrial village with roaring furnaces that employed no less than 1,500 people in work associated with the manufacture of pig iron and wire.

Between April 1979 and May 1980, the Angidy Ironworks site was excavated as part of a Job Creation Scheme managed by Gwent County Council through the Manpower Services

St Mary's Church on Chapel Hill in Tintern was built in 1866 and destroyed by fire in 1977. Many people who worked in the local iron industry are buried in the churchyard.

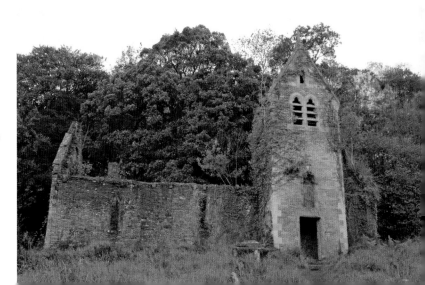

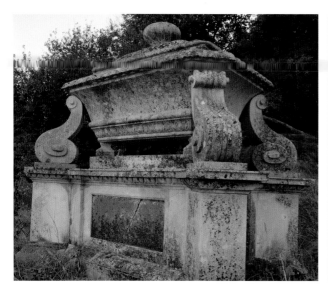
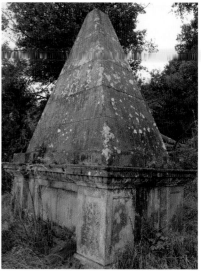

Above left: Known locally as the 'wine cooler tomb', this is the grave of Richard White, who ran the Tintern Ironworks until his death in 1765. The inscription states that he was 'inoffensive and benevolent and lived without an enemy. He died beloved by all'.

Above right: The 'pyramid tomb' is thought to be that of Robert Thompson, who leased Tintern Ironworks in 1799 and built New Tong Wireworks.

Commission, with grant aid from the Welsh Development Agency. The archaeologist in charge of the project was John Pickin, who subsequently produced a detailed report on his findings. Information panels were then erected on the site to provide an explanation of the ruins that had been exposed.

Coedithel Furnace – In Use for a Very Brief Period

The overgrown remains of a seventeenth-century blast furnace (no longer visible) are situated on the west side of the A466, on a hillside, about 30 feet above a stream. They consist of a 20-foot-high section of furnace with evidence of a waterwheel pit behind it.

Coedithel Furnace is now very overgrown. (MB)

The A466 was not built until 1803 so access to the site would have been by a track about 100 yards to the north, and there are traces of a watercourse running due west and north.

When excavated by R. F. Tylecote in 1966, this furnace was identified as being built in the mid-seventeenth century. It had an average weekly output of 18 tons between 1672 and 1676 and would have used iron ore from the Forest of Dean.

Sir Richard Catchmay, who lived at nearby Catchmay Court, was the original owner and the furnace was probably in production until about 1717.

Location: SO 527026

Trellech Furnace – Largely Forgotten and Concealed in a Wood

In Woolpitch Wood, near Trellech, are the remains of a very overgrown charcoal furnace and the best time to visit this site is in the winter. The furnace dates from about 1650 and is 26 feet square at the base. At a height of 10 feet from the ground it is about 20 feet square. Nearby Penarth Brook would have provided power for driving a waterwheel.

Location: ST 487048

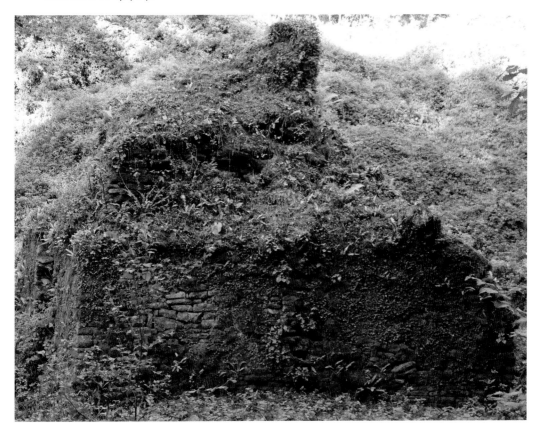

The overgrown remains of Trellech Furnace.

2

Ironworks and Steelworks

Pontypool – Regarded as the Home of South Wales Ironmaking

Ironmaking was carried out in this valley on a small scale as early as 1425, with forges established by David ap Ieuan Graunt, which means that the history of Pontypool predates the Industrial Revolution and the town can thus claim to be the home of the South Wales iron industry.

It was in 1570 with the arrival of Richard Hanbury, a London goldsmith and Worcestershire banker, that large-scale exploitation of the mineral wealth of this area began. He first acquired the ironworks at Monkswood, near Usk and Pontypool, which supplied the Osmond iron needed for wiremaking at Tintern.

By 1575 he was operating six or seven ironworks with charcoal-fired furnaces and when he died in 1608, his holdings in this area were valued at £5,000, but his last ten years were spent in retirement at Datchet in Buckinghamshire. He and his wife are buried at the local church, where they are commemorated by a brass memorial.

Since Richard had no son, his ironworks were inherited by his nephew and executor, John Hanbury of Purshall Green, Elmbridge, and on his death in 1658 his grandson, Capel, inherited the business and thus began his long association with Monmouthshire. He greatly improved the works at Pontypool and also purchased a substantial area of land on the east side of the Afon Lwyd where Pontypool Park House was later built, to become the seat of the Hanbury family for 250 years.

Capel's only son, John Hanbury, was born in 1664 and is best known as Major John Hanbury, having gained this military title on serving in the militia at the age of twenty-one. He was the first of the Hanburys to take up permanent residence at Pontypool and is celebrated as a pioneer in methods of iron production. He was well served by his subordinates and in particular his manager, Thomas Cooke, is said to have invented a method of manufacturing tin plates, by rolling them between water-powered iron rollers. These water-powered rollers replaced the labour-intensive process of manually hammering out wrought-iron bars into sheets. Twenty years later tinning was introduced and for a generation Pontypool had the monopoly of British tinplate.

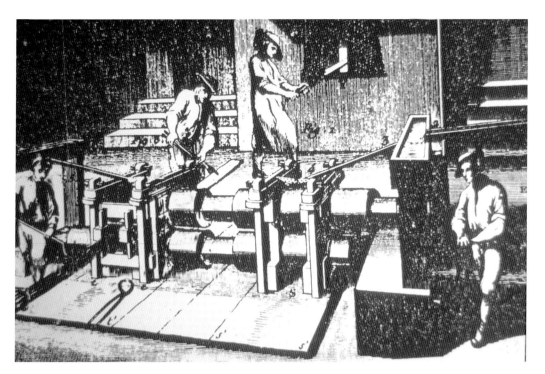

Thomas Cooke is said to have invented the rolling mill at Pontypool. It replaced the labour-intensive process of manually hammering out wrought-iron bars into sheets.

Thomas Allgood, who was employed as a manager of the Pontypool works during the early years of the eighteenth century, discovered a method of coating iron so that it resembled Japanese lacquered products. This process was subsequently developed by his son Edward, who set up a business in Trosnant in 1732 to produce Pontypool Japanware such as trays, tableware and chalices beautifully decorated with rich gilt effects. They became world famous and surviving examples of these articles are highly prized by collectors. A fine collection of them can be seen in Pontypool Museum.

In 1734, Major John Hanbury died and his third son, Capel Hanbury, took over. Under his direction the works gained an international reputation for the quality of its rolled iron plates, tin plates, nails and wire.

When Capel Hanbury Leigh succeeded to the family estates in 1795, he updated the works and in 1812 entered into partnership with the brilliant engineer Watkin George. During the Napoleonic Wars, the Pontypool works reached a peak of efficiency and prosperity. The partnership with Watkin George was dissolved in 1830 and by 1840 the works was losing £10,000 a year. In 1851, Capel Hanbury Leigh sold off some of his industrial interests, and the following year a decision was taken to lease their business interests to a Midland company. Five years later the lease passed to the Ebbw Vale Company, which before long abandoned steel manufacture in Pontypool.

Virtually all traces of the furnaces and ironworks in the vicinity of Pontypool have now vanished, but still to be seen, surrounded by 158 acres of beautiful woodland, is the old stately home of the Hanbury family, who as ironmasters had their seat here for over 300 years. In 1923, the Hanbury family sold this property to the Sisters of the Order of the

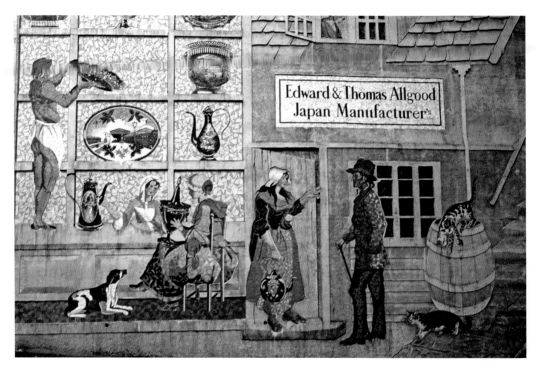

This mural in Crane Street underpass at Pontypool, made in 1993 by Ken and Oliver Budd, depicts the local Japanware industry.

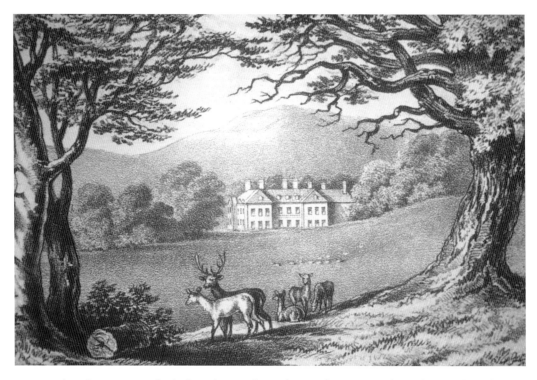

Pontypool Park House was built for John Hanbury during the 1690s and was later enlarged.

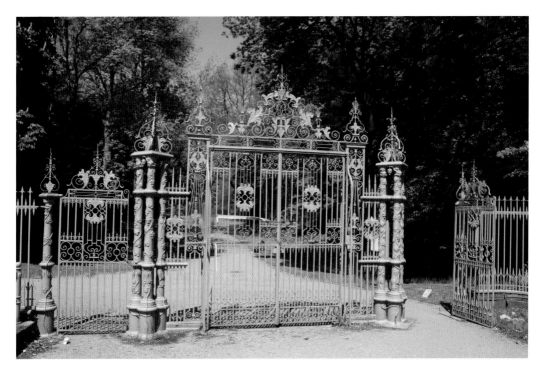

The wrought-iron gates at the entrance to Pontypool Park are a reminder of the past importance of Pontypool as a world-renowned centre of ironmaking.

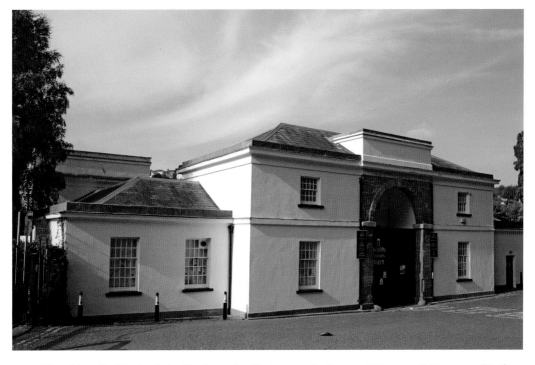

The old stable block of the Hanbury family is now the home of Pontypool Museum. (Torfaen Museum Trust).

Holy Ghost and it was initially opened as a day and boarding school for girls. The following year, it became the St Albans Roman Catholic High School.

To learn more about the history of Pontypool, visitors should make their way to Pontypool Museum, which is housed in the former Georgian stable block of Pontypool Park House and tells the story of the valley and its people from the earliest times to the present day, with emphasis on events that took place after 1780.

Location: SO 283011

Blaenavon Ironworks – The Finest Example of an Eighteenth-century Ironworks in Britain

An ironworks was established here in 1789 by Thomas Hill, Thomas Hopkins and Benjamin Pratt, who leased the land from the Earl of Abergavenny at a rent of £1,300 per year for a twenty-one-year term. It cost £40,000 to build and was the first purpose-built multi-furnace ironworks in Wales. By 1790 the three furnaces had started producing pig iron, which was initially transported by mules to Newport. Six years later the Monmouthshire Canal was opened between Pontnewynydd and Newport and this was linked with the Blaenavon Ironworks by a 6-mile tramroad down the Eastern Valley.

By 1806 the output of iron had reached 7,846 tons per year and this was now the third largest ironworks in South Wales, surpassed only by Cyfarthfa and Dowlais at Merthyr Tydful.

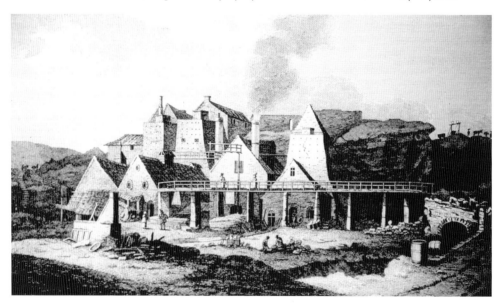

This engraving by William Byrne, based on a sketch by Sir Richard Colt Hoare, was made in August 1799. It depicts Blaenavon Ironworks as it appeared at that time. Three blast furnaces were built against a cliff to enable easy charging from above. Between the two furnaces is a blowing house, where a steam engine provided the blast. In front of the furnaces are the cast houses where the molten iron was run off into beds of sand to mould the lengths of pig iron. This illustration was published in William Coxe's book *An Historical Tour of Monmouthshire* (1801).

The furnaces were built into the hillside so that they could be easily charged from above. In the early days they were worked with open tops, with the gases being allowed to escape into the air, and at night the whole area was dramatically illuminated.

At the foot of each furnace, a cast house was constructed, where the white-hot molten iron was run off into beds of sand in order to mould the lengths of pig iron. The explanation for this name is that the casting channels and the row of pig moulds leading off them were said to resemble a sow feeding her piglets.

Close to the works stands a group of cottages known as Stack Square, which were built at the same time as the first furnace in 1789 in order to accommodate skilled workers who had been hired from the Midlands. These were the key workers who had previous experience of making iron. A three-storey house was built at the end of the square to accommodate the manager.

Dominating the site is an impressive water balance tower, which was built by James Ashwell in 1839 for the purpose of raising single trams loaded with pig iron 80 feet to the upper yard.

The loaded trams were raised by using water as an easily released counter-balance weight. Water in a tank under an empty tram at the top of the tower brought it down ready for loading and at the same time raised a loaded tram to the top of the tower, where it was transferred to the tramroad. The water in the container at the bottom of the tower was then drained and the weight of the descending tram returned the empty container back to the top of the tower.

The trams were then hauled by horses to the Pwlldu Tunnel and along Hill's Tramroad to the Garnddyrys Forge where the iron was refined and converted into finished products, which were then taken by horse-drawn trams to Llanfoist Wharf on the Brecknock & Abergavenny Canal.

Stack Square was named after a chimney stack that used to stand in the middle of the square.

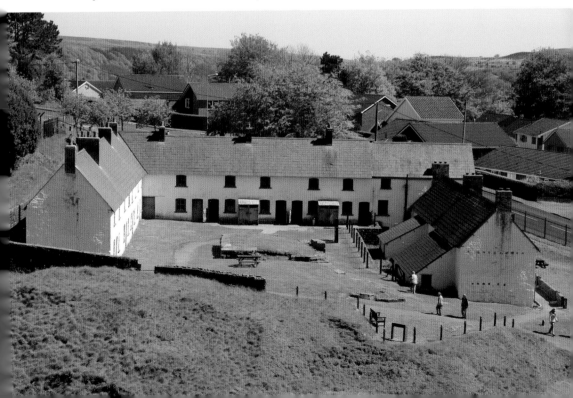

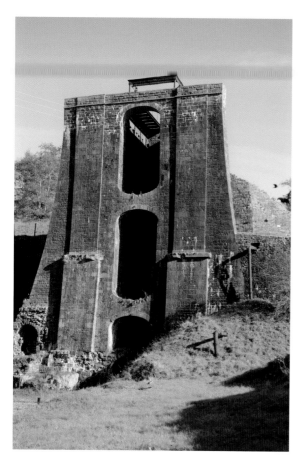

Left: Dominating the site is an impressive water balance tower, which was built by James Ashwell in 1839 for the purpose of raising single trams loaded with pig iron 80 feet to the upper yard.

Below: Garnddyrys Forge, situated at an altitude of 1,300 feet on the slopes of Blorenge Mountain, is where the pig iron was converted into wrought iron. (MB)

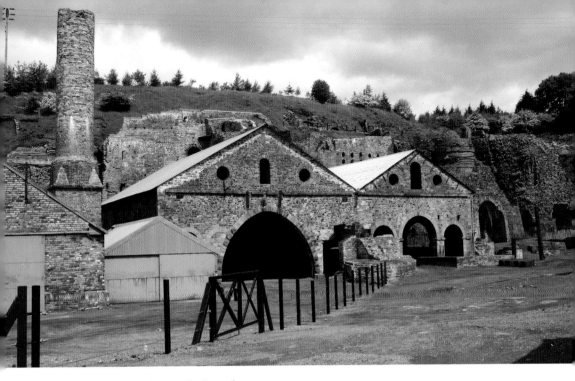

Blaenavon Ironworks as it looks today.

By 1860 Blaenavon Ironworks was superseded by a new works at Forgeside, beneath Coity Mountain, on the other side of the valley. Here there was more scope for expansion, and it was linked by steam railway to Pontypool and Newport, thus making the inefficient tramroad to Llanfoist Wharf obsolete. The days of ironmaking at Blaenavon ceased when the local ore supplies became exhausted. Steel markets became depressed and with the establishment of new steelworks near the coast relying on imported ores, the last furnace at Forgeside was closed down in 1934 and dismantled in 1938.

In the late 1960s the National Coal Board sold the ironworks site to Blaenavon Urban District Council for land reclamation. Stack Square was declared unfit for habitation and the residents rehoused. Fortunately, the ruined ironworks was taken into state care in 1971 and conservation began three years later. Today, as an important part of the Blaenavon World Heritage Site, it is a popular visitor attraction that is looked after by Cadw, the historic environmental service of the Welsh government.

Location: SO 249093

The British Ironworks – Once an Important Ironworks

Originally known as the Abersychan Ironworks, it was established in 1826 by Shears, Small and Taylor on land leased from the Wentsland estate. It became known as the British Iron Company in 1843 and when the works were taken over by the Ebbw Vale Iron Company the name was changed to New British Iron Company.

The works had six blast furnaces and in the early days the average weekly output was about 70–80 tons per furnace, with all the iron produced by cold blast. There were no coke ovens and all the coke used in the furnaces was made in the open air from large coal, the loss in coking amounting to 43 per cent. Four-fifths of the pig iron was refined and then, combined with the remaining fifth, passed through the puddling process for conversion into puddled bars.

Iron rails were first made at these works in 1840 and both rails and bars in various proportions continued to be made until 1850, when production of bars ceased, except for home use, and rails became the sole product, being in particular demand for the great railways of America.

In 1851, the British Iron Company went bankrupt after spending £400,000 on improvements to the works. Following a drop in prices the works was sold to the Ebbw Vale Company for £8,500, a paltry sum that represented just one-fifth of the value of the concern.

Various improvements, costing large sums of money, were carried out at the works by the Ebbw Vale Company, the most important being the application to the blast furnaces of the cup and cone technique. This arrangement enabled the waste gases to be collected and applied to the heating of the hot air stoves and blast engine boilers, for which purpose coal had previously been used.

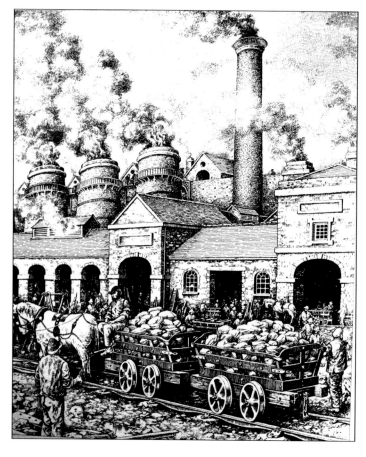

Reconstruction of the British Ironworks, established in 1825. (MB)

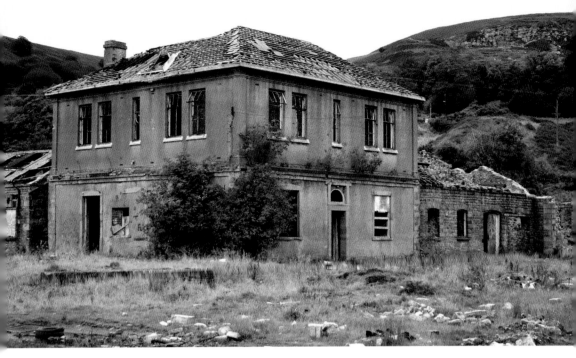

Above: Ruins of the Grade II listed office block, photographed by the author in 1996.

Below: The Cornish beam pumping house is now in a very dangerous state.

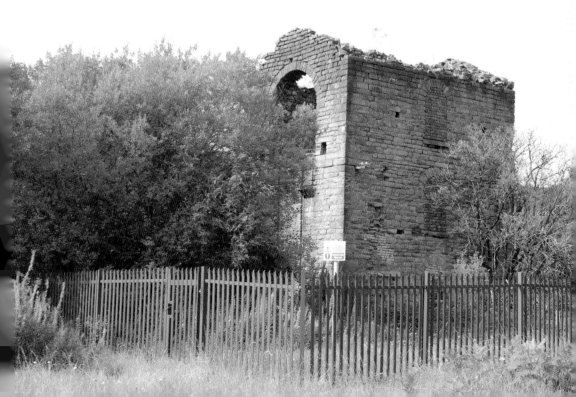

Access to this site is off the B4246 and through the 'Big Arch', a 50-yard tunnel passing beneath the embankment of the old Monmouthshire Railway, which was constructed in 1879.

When the demand for iron rails declined in about 1870 due to the popularity of steel, the British Ironworks went into decline and closed in 1876, putting a large number of people out of work. In 1878, the works were completely dismantled, the buildings, plant and machinery being broken up and sold.

Location: SO 258035

Clydach Ironworks – Built Just Five Years After Blaenavon Ironworks

Established in about 1795 to take advantage of local supplies of iron ore, coal and limestone, Clydach Ironworks were operated by the Hanbury family of Pontypool until 1797, when the widow of John Hanbury leased them to Edward Frere and Thomas Cooke, who also leased adjoining land from the Duke of Beaufort. Three years later they agreed to form a partnership with Edward and John Kendall of the Beaufort Works, which resulted in the Clydach Ironworks Company.

Edward Frere put thousands of pounds into the development of the works but further finance for the undertaking was always lacking. In 1803, Walter and John Powell joined

the company and introduced more capital. The partnership then went under the name of Frere, Cooke and Powell.

In 1813, the works was put up for sale and described as having: 'Two well constructed furnaces each capable of making 70 tons of iron per week', with blowing of the furnaces by means of 'Two capital Machines worked by water'. There were over 600 acres of land leased to the works, available for coal and iron, and worked by well-established levels.

Twenty years later the works was put up for sale again, with '3 blast furnaces, 44ft high and 14ft at the boshes, making 240 tons a week, with the blast supplied by a Boulton & Watt engine and a 42ft wheel'.

Messrs Powell now took over the works and by this time there were four blast furnaces, thirty-six coke ovens and a rolling mill. For the next twenty years the works did quite well and employed a large number of local people, but eventually the cost of bringing raw materials to it via a tramroad and incline proved uneconomic. By 1861 the works had ceased production.

During the latter half of the 1980s, Blaenau Gwent Borough Council, in conjunction with the Manpower Services Commission and Cadw (Welsh Historic Monuments), carried out a major excavation and restoration of the Clydach Ironworks, which had become buried under a huge quantity of dumped waste material and only the top part of the rear wall of a charging house was visible.

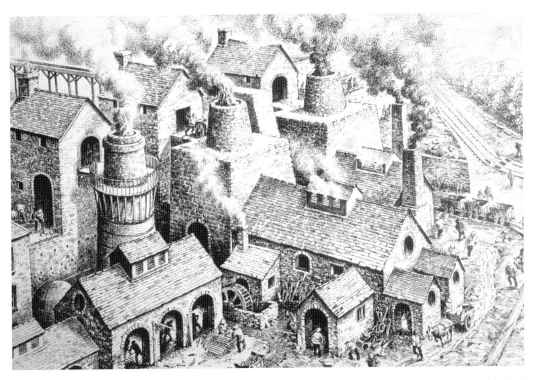

Reconstruction of Clydach Ironworks as it may have looked in the mid-1840s. It was established just six years after Blaenavon Ironworks and is a Grade II listed site. (MB)

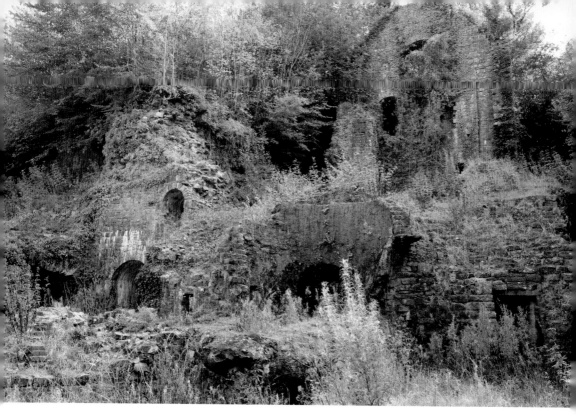

Clydach Ironworks was excavated in the 1980s, but nature is now taking it over. This picture was taken by the author in September 2020.

In due course the impressive remains of this early ironworks were opened to the public, but the site has been neglected in recent years, particularly during the work being carried out to reconstruct the A465 in the Clydach Gorge. It is hoped that in due course the ironworks site, which has been reclaimed by nature, will be put back into good order.

Location: SO 229132

Nantyglo Ironworks – Once One of the Most Important in the World

Nantyglo Ironworks was situated on land near the head of the Ebbw Fach river, to the south of Brynmawr, and its creation was due to the partners in the Blaenavon Iron Company. In order to fully exploit the mineral grounds that they were leasing from the Earl of Abergavenny, they made a proposal in 1791 to Harford, Partridge & Co. of Bristol that they should establish an ironworks at this location.

A formal deed of partnership was signed in April 1792 and two years later, R. S. Harford informed Thomas Hill, Director of the Blaenavon Iron Company, that the works was ready to start production, but within a year the works were standing idle.

In 1802, Thomas Hill formed a new partnership with Joseph Harrison and John Griffiths, and it became known as the 'Nantyglo Company', but due to a disagreement the works came to a stop by 1808. Three years later it was let to Joseph Bailey and Matthew Wayne at a rental of £2,050 a year, plus an annual charge of £750 for every furnace erected above three in number.

Matthew Wayne left the partnership in 1820 and Crawshay Bailey, the brother of Joseph, took his place. Under their management the works quickly developed with the construction of a new forge and rolling mill. Their five furnaces produced 17,500 tons of iron in 1823, rising to 23,883 tons in 1830 after more furnaces had been added. During this year the nearby Beaufort Ironworks was purchased for the sum of £45,000 and it was operated to supply pig iron to the puddling furnaces and rolling mills at Nantyglo.

The firm of J&C Bailey quickly attained a worldwide reputation. The demand for their iron rails was insatiable in the 1840s, with the first railways in North America all owing their existence to the Nantyglo Ironworks.

Crawshay Bailey retired in 1850 and left his nephews Richard and Henry Bailey to manage the Nantyglo and Beaufort works, but no doubt kept a very careful eye on them. In 1871, the Bailey Brothers sold their business to the Blaina Iron & Coal Company just as the demand for iron peaked. The Nantyglo Ironworks by then had fourteen blast furnaces, sixty-seven puddling furnaces and four rolling mills. A decline in the market for iron, caused mainly by the imports of cheap ore from Spain and the failure to convert to the new steelmaking process, resulted in the closure of Beaufort Ironworks in 1873 and Nantyglo closed the following year.

Today, the only surviving building that was once part of the Nantyglo Ironworks is one of the cast houses, which was subsequently used as a Sunday school and is now a private

Nantyglo Ironworks, depicted by Henry Gastineau in 1835.

The only surviving building of the Nantyglo Ironworks is one of the old cast houses.

house. Otherwise, all visible traces of this huge ironworks have been obliterated by later developments and reclamation.

Location: SO 193100

Sirhowy Ironworks – The First in Gwent with Coke-fired Furnaces

The Sirhowy Ironworks lies at the head of the Sirhowy Valley, 1 mile north of Tredegar and near the confluence of Nant Melin Brook and the River Sirhowy at the place called Aber Sirhowy.

In 1778, local landowner C. H. Burgh had granted a forty-year lease on land in this locality to a partnership comprising Thomas Atkinson, William Borrow, John Sealy and Bolton Hudson. It allowed them 'full liberty to build Furnaces, Forges, Mills, Engines and Storehouses'.

The site they chose for their venture was ideal as there were more than enough raw materials available locally for the ironmaking process. There was also a plentiful supply of water, which came from the streams and springs running down the mountains.

Their coke-fired furnace had an initial output of about 4 tons a week, which was gradually increased to 10 tons a week. However, the partnership collapsed in 1794 and Borrow, the surviving member, sought new partners. He was joined by Matthew Monkhouse, a Bristol clergyman, and Richard Fothergill, a merchant banker from London, who both wished to invest their money in an ironworks.

It became known as the Sirhowy Ironworks and by 1796 was producing 1,820 tons of iron a year, which at that time was an impressive amount. A second blast furnace was constructed the following year and a Boulton and Watt steam engine installed.

There were five furnaces on the site by 1844, and the output was 7,000 tons a year, with a workforce of nearly a thousand, but in 1883 ironmaking ceased at Sirhowy because steel was the metal now in demand and it would be uneconomic to adapt the works for this purpose. The blast furnaces were no longer needed but the coke ovens continued to make coke for Ebbw Vale until 1905.

Land reclamation in 1971 obliterated 85 per cent of the works area and three of the five furnaces were destroyed as well as the blowing house and the casting floors. The coke ovens and calcining kilns situated above the furnaces were also lost.

In 1977, Sirhowy Ironworks was excavated by a team of local men sponsored by the Manpower Services Commission and headed by John Pickin, a qualified archaeologist. The purpose behind the project was to uncover a site that was undoubtedly important to local history, but also to provide much needed work for several unemployed men in that area.

Very few ironworks had been excavated at this time so the work done at Sirhowy would undoubtedly be useful for the interpretation of other works that were planned to be excavated in due course.

The surviving three large masonry and brick arches were designed as support structures for a massive wall, which would have supported the charging platform where the raw materials for the furnaces were prepared. A large circular opening in the roof of the central arch held a pneumatic hoist, which worked off the blast main, to carry materials from the charging platform to the mouth of Furnace 1.

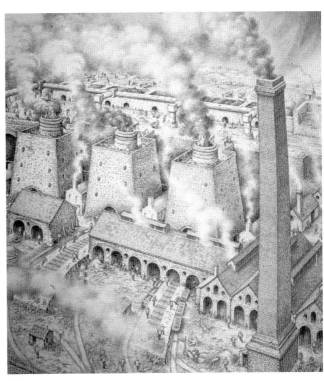

Reconstruction of the Sirhowy Ironworks, which was the first in Gwent to be fuelled by coke. (MB)

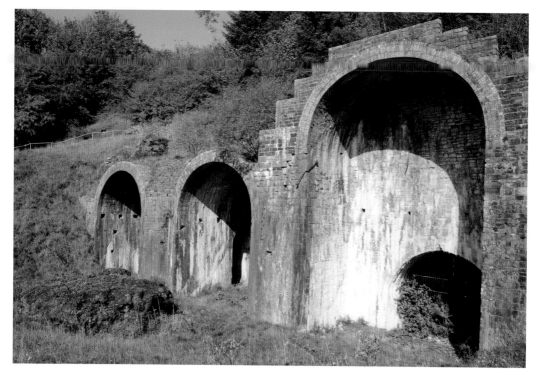

Much of the site was obliterated by land reclamation in 1971, but an excavation in 1977 revealed some of the stone structures of this once important ironworks.

On the site of one furnace is the 'bear', a mixture of iron, slag, brick and unburnt coke which accumulates in a furnace after a period of use. When the furnace was in use, the 'bear' had to be removed from time to time, but when the furnace was abandoned there was no incentive to undertake this difficult task.

Sirhowy Ironworks is important historically because it had been operated for over a century and was an early user of steam power for blast furnace blowing. The first known use of steam power for this purpose was in 1776 when John Wilkinson applied a Boulton & Watt engine to his furnace at New Willey in Shropshire. South Wales got its first engine of this type at Neath Abbey Ironworks in 1793. Sirhowy followed in 1798 and between that year and 1801 others were erected at Blaenavon, Dowlais, Penydarren, Rhymney, Sirhowy and Tredegar.

Location: SO 143102

Tredegar Ironworks – One of Few in Gwent to Change to Steel Production

In 1801, production started at a new ironworks half a mile down the valley from the Sirhowy Ironworks at Uwchlaw-y-coed. Named Tredegar Ironworks after Tredegar House, the home of Sir Charles Morgan, it was built on land that he owned in Glyn Sirhowy. In due course Tredegar Ironworks became the postal name of the new town which grew up around these ironworks.

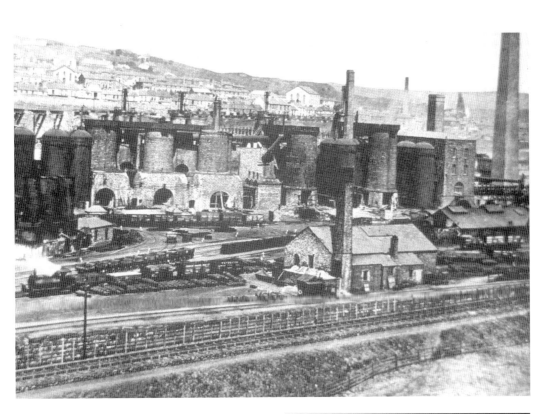

Above: Tredegar Ironworks was established in 1801 on land owned by Sir Charles Morgan.

Right: Tredegar Clock, an iconic symbol of the town's iron industry, was erected in the mid-nineteenth century on the site of the old Tredegar Market Place to commemorate the Duke of Wellington, whose profile is shown on the massive base. It is significant that this clock tower is made of iron for it was upon iron that Tredegar's economy was founded. Manufactured by Charles Jordan, a Newport ironfounder, the sections of the tower were brought to Tredegar via the Sirhowy Tramroad, which is an achievement in itself for the structure is 72 feet in height and many tons in weight. It has four transparent faces, each 5 feet 3 inches in diameter, and illuminated originally by gas but later by electricity. Designed by J. B. Joyce of Whitchurch, Shropshire, it chimes on the hour and on the half hour and can be heard throughout the town. If you only visit Tredegar once you will undoubtedly remember the town for its distinctive clock.

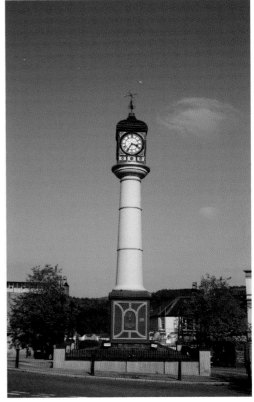

Between 1822 and 1854, several locomotives were built at Tredegar Ironworks for use on the Sirhowy Tramroad, which included *Tredegar, Jane, Lord Rodney, St David, Lady Sail,* and *Bedwellty.* Daniel Gooch, a young employee at Tredegar Ironworks, even went on to become chief engineer on the Great Western Railway.

In 1882, the Tredegar Iron & Coal Company changed over to steelmaking and the older furnaces were decommissioned. The new ones were iron-clad and of greater capacity. The output became considerable, and with the boom in the steel trade in 1884 it was virtually trebled. The climax in trade came in 1890, but this was followed by a steady decline until the works finally closed in 1895. There are no remains of this ironworks to be seen today.

Ebbw Vale Iron and Steelworks – Successfully Changed Over to Steelmaking

Prior to 1790 this location was no more than a hamlet beside the River Ebbw, so the town owes its existence to the Industrial Revolution. Within a hundred years the population rose from about 130 to 12,000.

The first coke-fired blast furnace was set up here in 1790 by Jeremiah Homfray of Penydarren Ironworks near Merthyr Tydful. The pig iron produced was initially sold to other ironmasters in the neighbourhood who had already established puddling furnaces and mills but were not making sufficient pig iron to keep them going.

In 1793, Homfray was joined by the Harfords, whose capital enabled the business to expand. During the next three years the firm cast rails for the Trefil Tramway Company, who were constructing a tramroad to convey limestone from the Trefil Quarries, 4 miles to the north of Ebbw Vale.

Homfray pulled out of his partnership with the Harfords in 1796 and the works continued to develop under the name of Harford, Partridge & Company. In 1818, they purchased the Sirhowy Ironworks and developed the Ebbw Vale Works by erecting extensive puddling furnaces and bar plate mills.

In 1844, the works was bought by Messrs Darby of Coalbrookdale. The partners at that time were Abraham Darby, Henry Dickenson, Joseph Robinson, J. Tothill and Thomas Brown, the last named being the managing partner of the concern. The great-grandfather of Abraham Darby had founded the famous Coalbrookdale Ironworks in 1766 and the name of this family is still remembered in Ebbw Vale with 'Darby Crescent'.

George Parry, the works chemist at Ebbw Vale, was the first to successfully adopt the cap and cone on the blast furnaces for utilising the waste heat which escaped with the volume of flame issuing from the mouth of the furnace. This technique enabled the boilers supplying steam to the blast engines to be heated and also the blast before it entered the furnaces. It resulted in considerable economy in blast furnace operation.

In 1852, the Ebbw Vale Company bought the Abersychan Ironworks from the British Iron Company. They paid the trifling sum of £8,500 for these works, which was more than covered by the stock of manufactured goods. The company further extended their holdings in 1855 with the purchase of an extensive iron tinplate works and collieries in Pontypool.

Thomas Brown, the managing partner, applied for a licence in 1856 to make Bessemer Steel, which had been pioneered by Sir Henry Bessemer. It is significant that Ebbw Vale

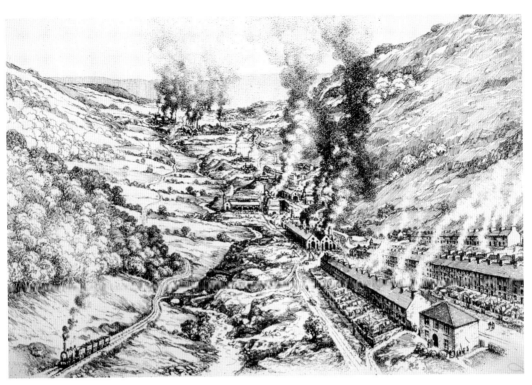

Ebbw Vale Steelworks was 2.5 miles long and employed more than half of the working men of the town. (MB)

was one of the first works to use the Bessemer Process and in due course was followed by Rhymney and Blaenavon.

The change over from iron to steel resulted in the bottom dropping out of the market for iron and those works that were unable or unwilling to finance the costly move to steelmaking went into decline and eventually closed down. The only inland works to survive into the modern period was Ebbw Vale.

In 1862, Thomas Brown retired from the management of the works and was succeeded by Abraham Darby as managing partner. By this time the Ebbw Vale Company had, at their huge works, 192 puddling furnaces, 99 heating furnaces, 1,200 workmen's cottages and colliery leases comprising 7,500 acres of land.

In 1864, the whole concern was converted into a new company, which was formed with a capital of £4,000,000 in shares of £50 each. The whole concern was placed under the managing Directorate of Abraham Darby and the General Management of William Adams. In 1865 Abraham Darby erected a new and powerful blast engine on the south side of the Ebbw Vale blast furnaces and it became known as the 'Darby'.

In the following year, the company was reconstructed with the founding of Ebbw Vale Steel, Iron and Coal Company Ltd. The works was converted to just steel production during the next two years, which enabled it to progress into the twentieth century.

Abraham Darby retired from the management of the works in 1873 and was succeeded by Windsor Richards, who resigned the position two years later and Mr J. F. Rowbotham took over as manager.

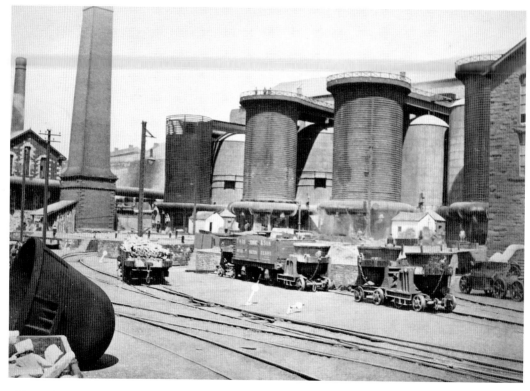

Ebbw Vale blast furnaces. (CB collection)

During the Depression of 1920–30, the steelworks was closed and around a third of the town was left unemployed. Against all the odds a new steelworks came to Ebbw Vale in 1938, established by Richard Thomas, and was the most modern in Europe, with the first hot strip mill. By the end of the 1940s Richard Thomas had merged with Baldwins to become RTB and further advances took place in steelmaking.

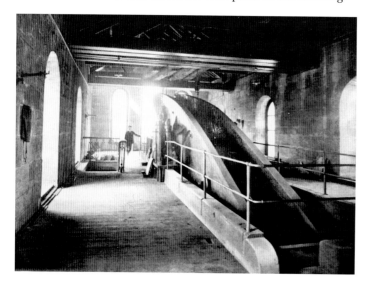

Beam of the Darby blowing engine for Ebbw Vale blast furnaces. (CB collection)

Over 6,000 men were now employed in the company's vast rolling mills, huge factories and steel sections and in 1947 this was one of the first works to have an electricalitic tin line, a new invention brought in from America, which made the Ebbw Vale works the specialists in tinplate processing.

By 1960, Ebbw Vale employed 9,000 people and was the largest completely integrated iron, steel sheet and tinplate works in Britain. The works pioneered the LD oxygen method of steelmaking in Britain and was soon producing over a million tons of steel a year.

The industry was, however, facing increasing competition from overseas and steel production was drawn to coastal sites where transport costs were much lower. In 1962, a new modern steelworks opened at Llanwern, near Newport, and this was where the future lay. By 1967 the steel industry was nationalised, becoming the British Steel Corporation.

Ebbw Vale's continuous strip mill rolled its last hot rolled coil on 29 September 1977, having rolled 23 million tons of steel since first being commissioned in 1937. Steelmaking ceased at Ebbw Vale in 1978, with 5,000 people made redundant.

Demolition of the works began in August 1979 and took eight years to complete. In 1986 work began in preparing part of the steelworks site for the 1992 National Garden Festival. Situated 1,200 feet above sea level and 2 miles long, the festival was very successful, receiving 2 million visitors, and on its closure the site was used for the construction of a shopping centre and housing.

Then in October 1999 a merger was made with Hoogovens (Holland) and British Steel plc to form a new company called Corus in order to produce tinplate. However, times had changed, and tinplate production was mainly now carried out by newly expanding works in Asia, so it was no longer economic to do it at Ebbw Vale.

On 1 February 2001, Corus announced the complete closure of the Ebbw Vale site with the loss of 780 jobs and by July 2002 the steelworks site was completely closed. This brought to a close 200 years of iron and steel production in the western valley of Old Monmouthshire.

Location: SO173090 – The Works (Archive and Museum)

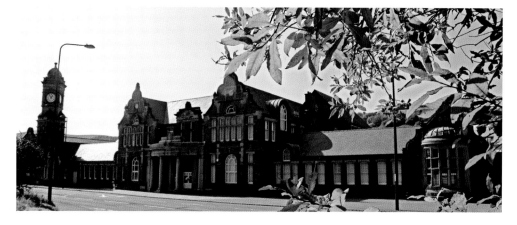

The former steelworks general office is Grade II listed and has been retained as a museum, archive and visitor centre, known as 'The Works'. It was officially opened by Elizabeth II on 3 May 2012. (AMB)

3

Extraction of Raw Materials

The area along the heads of the valleys could provide all the materials needed for making iron: iron ore, charcoal for smelting (from the abundantly wooded hillsides) and, in later times, coal and limestone.

In the early days of blast furnaces, charcoal was the only fuel that could be used safely, without introducing impurities into the ore and producing iron that was too brittle for working. Gradually after 1750, coke became widely used as a fuel for smelting and within the next ten years the technique spread rapidly with many new coak-fired furnaces being established. For this reason the Industrial Revolution is generally dated from 1780 to 1830.

Ironstone

Thinly covered by soil, the ironstone was easily obtained by a technique known as 'scouring'. After removing an area of turf, the top soil was cleared away by releasing a surge of water above it. By constructing an earthen dam, a lake could be formed and when the

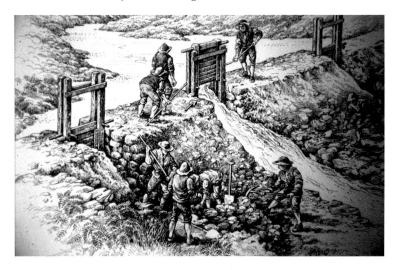

This technique for scouring iron ore was undertaken during the early years of the Industrial Revolution. (MB)

dam was breached the water gushed down and scoured the soil away to reveal the iron ore within large stone nodules. Thousands of tons of earth and stone were removed in this way with very little physical effort.

When the more easily reached ironstone became exhausted it was then necessary to reach even greater depths by driving levels into the hillsides. The levels were usually named after individual miners who were responsible for these undertakings in the relentless quest for ironstone and coal.

A report written in 1839 reveals that it was necessary to mine about 15 tons of shale in order to produce 1 ton of ironstone, and it took 3 tons of ironstone 21 tons of coal and 1 ton of limestone to produce 1 ton of pig iron. Over a period of 200 years the amount of mining activity that took place on the hillsides, such as those in the Blaenavon area, was quite extraordinary.

The local name for ironstone was 'Welsh Mine' and in 1800 it cost 5s a ton. By 1830 the cost had risen to between 8s and 9s a ton. This rose to 14s a ton by the mid-1850s and it then became cheaper to use imported ironstone, which contained double the amount of ore than the local ironstone and the pig iron produced was less brittle.

Coal

In the last decade of the eighteenth century coal began to play an increasingly important part in the production of iron. Initially coal was worked in patches where it outcropped on the surface, but when the excavation became too extensive and tended to collapse these shallow workings were abandoned. Drifts, long inclined tunnels, were then driven into the hillsides, following the slope of the seam and as they ran up into the outcrop they were generally self-draining.

Saucer-shaped depressions in the ground mark the collapse of bell pits, which was another way of obtaining coal. The name is derived from a section view of the pit which

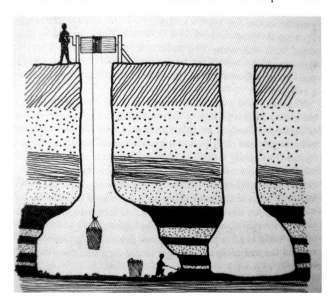

Coal extraction by the use of bell pits.

resembles a bell. These pits were rarely more than 20 feet deep and about 6 feet diameter at the top and widening towards the bottom.

Until about 1840, coal was won by the 'Pillar and Stall' system, which was common practice throughout the South Wales mining areas. It involved working in stalls 8 yards or so in width, with 6 or 8 yards of a pillar of coal between each stall, worked by a man to each stall.

In 1849, Thomas Deakin of Blaenavon commended the extra safety and economy of the long-wall system. With this, a whole face was working as one operation and no supporting pillars were left behind.

Limestone

Limestone was needed as a flux in the ironmaking process and its availability contributed to the swift growth of ironworks at the heads of the industrial valleys of Gwent and Glamorgan during the late eighteenth and early nineteenth centuries. In 1788, large limestone quarries were beginning to be opened up on the northern edge of the heads of the valleys.

Pwlldu Quarry was established at the head of Cwm Llanwenarth, to the north of Blaenavon, in the first decades of the nineteenth century to provide limestone for the newly erected furnaces of Blaenavon Ironworks. It is exceptionally well preserved and is a Scheduled

Pwlldu Limestone Quarry at the head of Cwm Llanwenarth, to the north of Blaenavon, is exceptionally well preserved and has been designated a Scheduled Ancient Monument because of its water balance lift system, which is a unique feature in any quarry.

Ancient Monument. Of special interest is the shaft of a water-balance lift system through which trams loaded with limestone were raised 100 feet to a tramroad at a higher level.

Location: SO 250115

Trefil Quarry to the north of Tredegar is one of the largest in Gwent and took its name from the nearby village. It was first developed in the 1790s by Edward and Jonathan Kendall to supply limestone to their ironworks at Beaufort. Later on it also supplied ironworks at Sirhowy, Tredegar, Ebbw Vale and Rhymni. Between 1813 and 1820 Ebbw Vale extracted 41,000 tons of limestone and it continued to supply the modern steelworks at Ebbw Vale until it closed in 1974. It is now a Scheduled Monument because of its importance in the development of the iron industry in this part of Wales.

Location: SO 117140.

Trefil Limestone Quarry, to the north of Tredegar, was first developed in the 1790s to supply limestone to Beaufort Ironworks. It is a Scheduled Monument and the most important quarry in Gwent. Limestone acted as a flux, encouraging the impurities to coalesce as slag.

4

Ironmasters' Mansions and Workers' Cottages

Pontypool Park House – Ancestral Home of the Hanbury Family

Construction of this large mansion was started by Capel Hanbury in 1670 and completed by 1694. It was then extended between 1752 and 1765 with a low fronted and taller addition behind the original house. Further improvements were made by Capel Hanbury Leigh, whose extensions were completed by 1810. It remained the Hanbury's family home until 1930, when they gave the house and its grounds to the town. The house is now a comprehensive school.

Location: SO 283010

Pontypool Park House was begun by Capel Hanbury in 1670, extended between 1752 and 1765 and further improved by Capel Hanbury Leigh to be completed by 1810. It remained the Hanbury family residence until 1830 and is now a comprehensive school.

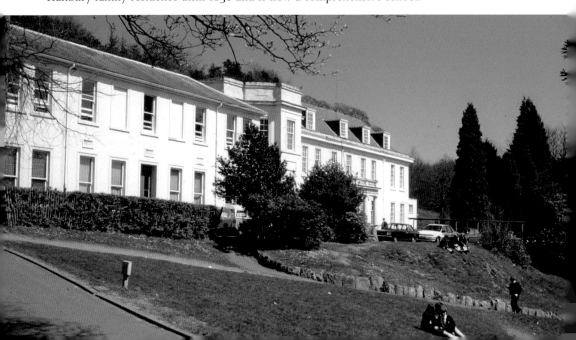

Ty Mawr, Nantyglo – Last Privately Built Fortified Residence in Britain

This grand mansion was built in 1811 by Joseph Bailey, owner of the Nantyglo Ironworks. It stood on made-up ground, which provided the Baileys with a splendid southerly view while being sheltered from the sounds and smells of the works.

The driveway led through an avenue of trees and the house was surrounded by large gardens. It had a fine colonnaded front supported by six iron pillars, cast in their own works, and inside was a magnificent marble staircase.

Joseph Bailey must have felt uneasy in his grand mansion after the Merthyr uprising and in order to provide protection in times of trouble, he constructed two fortified towers, which were kept stocked with food and ammunition, and here the Bailey family could take refuge and withstand a siege until the Redcoats arrived.

It has been claimed that Ty Mawr was linked with one of the towers by an underground passage, but this has yet to be discovered.

Please note: the site is under private ownership and is part of a working farm, so at present there is no access to the round towers, but they can be seen from a nearby bridleway.

Joseph Bailey retired to an estate in the Usk Valley, but Crawshay Bailey lived at this Nantyglo mansion until 1860 when he moved to Llanfoist House in the Usk Valley. Ty Mawr was then occupied by a series of managers and the last one to live there was Samuel Lancaster of Blaina, who died in 1855. In 1900, there was a proposal to turn the empty

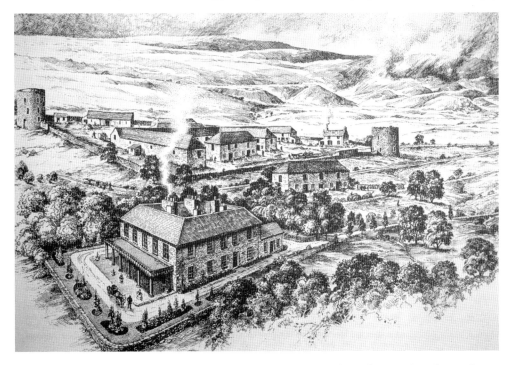

Reconstruction of Ty Mawr, Nantyglo, which was built in around 1816 by Joseph Bailey, with two round towers to guard the estate and provide refuge in times of trouble. (MB)

Left: The North Round Tower, near the estate entrance.

Below: The South Round Tower was originally one storey higher but was partly demolished in the 1940s to salvage scrap iron.

house into a hospital, but a local doctor opposed the idea, claiming that it was too near an open sewer. Eventually Ty Mawr was demolished during the Second World War and the stone used for building purposes and road construction. All that can be seen of the house now is an excavated area with the foundations and cellars of the building well defined.

Location: SO 190102

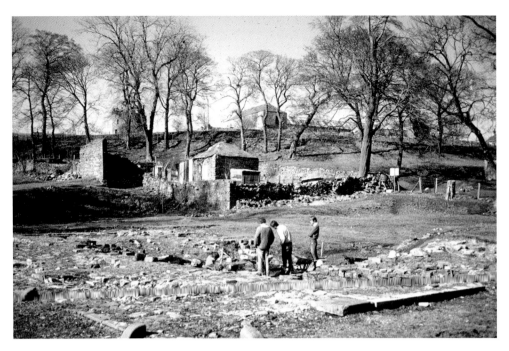

An excavation at Ty Mawr in the 1980s revealed its foundations.

Bedwellty House – Gwent's Finest Surviving Example of an Ironmaster's Residence

Bedwellty House, Tredegar, was originally built in 1800 on the lands of Coedcae y Cynhordy by Samuel Homfray, who was a partner in the Tredegar Ironworks. It was reconstructed in 1818 by Samuel Homfray Jr following his appointment as manager of the Tredegar Ironworks. He had married the widowed daughter of Sir Charles Morgan but died without issue, so in

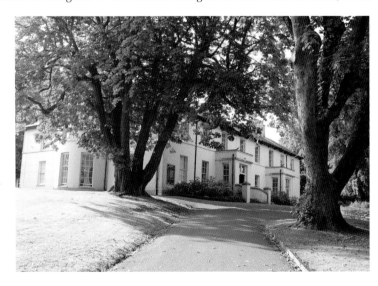

Bedwellty House in Tredegar is a magnificent ironmaster's mansion built in 1818 by Samuel Homfray Jr in 1818. Now owned by Blaenau Gwent Council, it stands in 26 acres of parkland and is open to the public.

due course the house, with its two entrance lodges and 26 acres of parkland, was passed on to the Morgan family of Tredegar Park, Newport. It was reserved for occupation by managers of the Tredegar Iron and Coal Company until 1901. There are twenty spacious and beautifully fitted rooms while the outbuildings include stables, a coach house and an icehouse.

A marble tablet set into the wall at the southern entrance to Bedwellty Park commemorates the gift of Bedwellty House and its parkland to the town by Lord Tredegar in 1901.

Location: SO 144085

Ty Mawr, Blaenavon – Home of Samuel Hopkins, the Blaenavon Ironmaster

Ty Mawr in Church Road, Blaenavon, was built in 1800 by Samuel Hopkins and in his time it was known as Blaenavon House to distinguish it from his second home in Nevill Street, Abergavenny, where he often stayed when he wished to indulge in the social life of that town.

In later years, Ty Mawr was used by subsequent directors of the Blaenavon Company as their official residence. In 1925, the company decided that they no longer needed Ty Mawr and it was leased to the local Medical Society, who converted it into a hospital. It was last

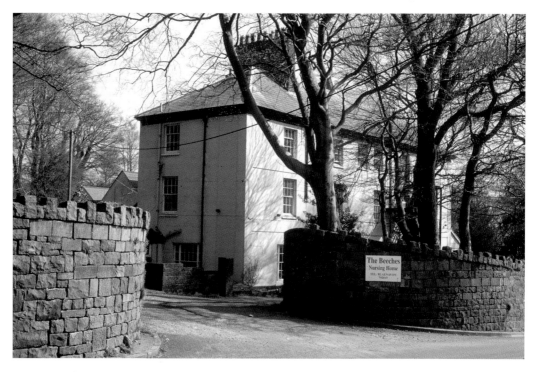

Ty Mawr, Blaenavon, was built in 1800 by Samuel Hopkins, the Blaenavon ironmaster. After his death it was used by subsequent directors of the Blaenavon Company, later as a hospital and then a nursing home. Now derelict, it is privately owned and a listed building awaiting restoration.

used as a private nursing home called 'The Beeches', but when that closed it remained empty for many years and is now in a derelict state.

Location: SO 143085

Workers' Cottages

Not only did the ironmasters own the ironworks and coal workings, but also the hovels that had been built to accommodate their large number of workers. As there were no building restrictions, houses could be put up in any fashion, so they were often built back-to-back. There were no regulations to prevent overcrowding, as shown by a report of 1830, which listed one house with seventeen people living in a single room.

Most of the early workers' houses had no sanitation, while some had a privy set over a cesspit that was shared by several households. No consideration was given to providing main drainage and as there were no arrangements for the disposal of household refuge it accumulated in the streets in great heaps. Water running off waste-strewn land around the works and housing polluted the wells and streams that supplied drinking water, which led to outbreaks of disease such as typhoid and cholera.

Cefn Golau Cemetery – Established in a Remote Location for Cholera Victims
Above Tredegar, high on the hillside known as Cefn Golau (the Hill of Light), is a special cemetery created for cholera victims. This dreadful disease first hit the town in the autumn of 1832 and lasted until the spring of the following year. It broke out again December 1849 and in less than a month there was scarcely a street in the town that was not affected.

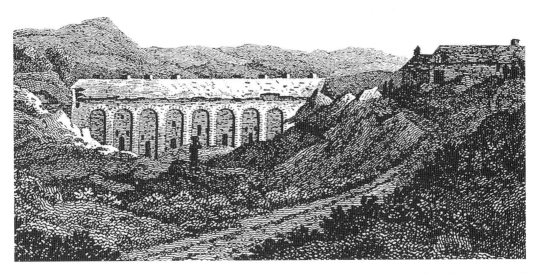

This drawing by Sir Richard Colt Hoare in 1799, near Blaenavon Ironworks, shows a covered bridge carrying a railroad and supported by ten arches, which had been bricked up to provide very basic dwellings for industrial workers.

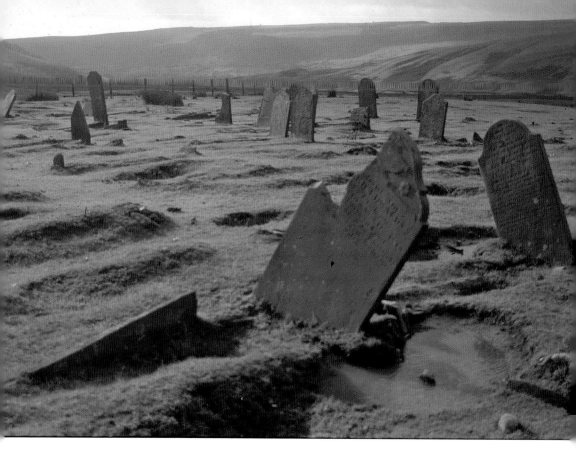

Cefn Golau cholera cemetery above Tredegar is a Scheduled Ancient Monument.

The authorities closed the chapel graveyards and opened this isolated burial ground away from the town. It is a moving experience to come here on a misty day, for Cefn Golau is a neglected and forlorn place, where leaning gravestones, inscribed mainly in Welsh, provide a sad reminder of the days when good sanitation was unheard of and all the local community had to drink was contaminated water.

Location: SO 138081

Forge Row, Cwmavon – Another Example of Good Housing for Workers

This terrace of twelve cottages was constructed in 1802 by the Blaenavon Company and is perched on the hillside just above the site of the long vanished Cwmavon Forge. Just like Stack Square, it is a fine example of housing from the first phase of the Industrial Revolution in Gwent. It is interesting that this was the first workers' housing in South Wales to have back doors. In 1980, Forge Row was in danger of demolition, but a unique scheme instigated by the British Historic Buildings Trust and the National Trust resulted in the terrace being purchased and restored in 1989, at a cost of £200,000, thus ensuring their survival. The cottages were sold and are now privately owned.

Location: SO 270064

44

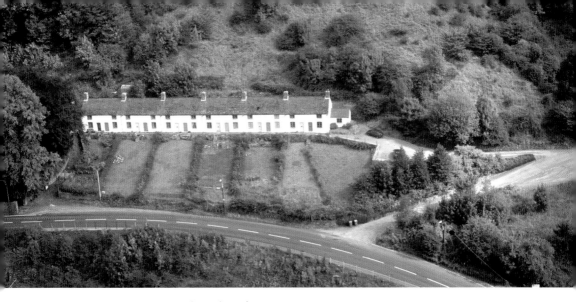

Forge Row, Cwmavon, consists of twelve cottages constructed by the Blaenavon Company in 1802. These were the first workers' housing in South Wales to have back doors. They were restored in 1989 and are now privately owned.

Stack Square, Blaenavon – Built for Highly Skilled Workers

This group of cottages built at Blaenavon Ironworks between 1789 and 1792 consists of two parallel rows of houses joined by a third range of buildings, which in the early period contained the company shop and offices. The square was built to house skilled workers brought here from the Midlands. For the standards of that time, this was industrial housing of high quality with two rooms on each floor and a larder. They were 'privileged' residences for the foremen and important workers who were essential to the running of the nearby furnaces.

By 1970, Stack Square was derelict, but the cottages have since been restored and partially furnished in the style of various time periods and are open to the public as part of the ironworks visitor experience.

Location: SO 251095

The cottages in Stack Square, built at Blaenavon Ironworks in around 1798, had good-sized rooms for the time – four in total – and even a larder.

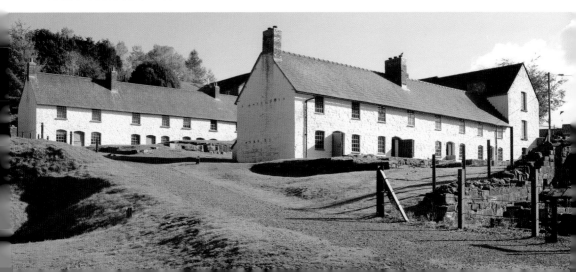

5

Collieries in Gwent

When coal converted into coke started being used as a fuel in the ironmaking process, it was given a new importance and demand increased. Coal mining was then seen as an industry in its own right, and output trebled in the decade following 1840. It had commenced as little more than a subsidiary to the working of ironstone, but the coal industry was to become the largest and most important business in the whole of South Wales.

From 1800 pits were sunk in quick succession, beginning in the northern outcrop coal areas of Monmouthshire, at Tredegar, Blaenavon, Nantyglo, Blaina and Ebbw Vale. Development of collieries then took place in the adjoining districts of Abertillery, Bedwellty, Pontypool, Risca and Cwmbran. A map drawn by John Prudeau in 1843 shows fifty-three collieries in Monmouthshire: twenty-four in the Western Valley, twenty-one in the Sirhowy Valley and eight in the Eastern Valley.

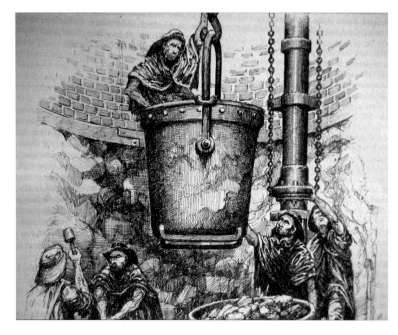

Sinking a pit was a dangerous job, and men were frequently killed. (MB)

In due course there were more than 150 collieries in these areas, and by 1909 there were 44,298 colliers employed cutting coal, while 7,175 men worked above ground attending to the engines, coke ovens, etc. Numerous towns and villages owe their origin to coal mines. The chief centres of coal mining in this area were Abercarn, Abersychan, Abertillery, Bedwellty, Blaenavon, Blaina, Ebbw Vale, Nantyglo, Pontypool, Rhymney, Risca, Sirhowy, Tredegar and Varteg.

Big Pit – One of the Oldest Shaft Mines in the South Wales Coalfield

Big Pit (Pwll Mawr) stands on the site of an earlier mine called Kearsley's Pit, the shaft of which was sunk to a depth of 128 feet in 1860. It was with the deepening of this shaft to the present depth of 293 feet in 1880 that 'Big Pit' came into being. It took its new name from the size of the elliptical shaft, which measures 18 feet by 15 feet and was the first in the area wide enough to wind two trams of coal side by side.

Coal mined at Blaenavon had special qualities. In particular, it had great steam raising power with low ash and an unusually low percentage of sulphur. The latter prevented clinkering on the bars of iron thus saving labour and waste.

Originally Blaenavon coal was used mainly in the iron furnaces and also supplied neighbouring towns with household fuel, but in later years it was in great demand for powering steamships and railway locomotives. The two pioneer railways of England, the London & North Western and the Great Western, were both regular customers. The first railway system in France, the Chemin de fer de L'ouest, used Blaenavon coal and it was

Big Pit National Coal Mining Museum.

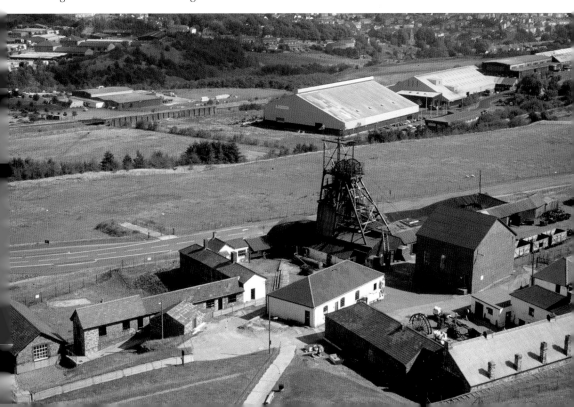

also shipped to South America for consumption on their railways. By the early twentieth century Blaenavon with its numerous collieries was producing 500,000 tons of coal a year.

Nine different seams of coal were worked at Big Pit at one stage but by 1973 the last seam of coal being worked was the Garw, just 2 feet 4 inches height, and this meant that the men had to work lying flat on their sides along the face in cold and wet conditions. Not only was the seam too thin, but it was very difficult extracting the coal.

On 3 February 1980, Big Pit stopped producing coal altogether, owing to an exhaustion of workable reserves. One hundred years old, it was the oldest working mine in South Wales.

The seventy-six remaining men were transferred to neighbouring collieries and the bottom levels of Big Pit, 500 feet down, were allowed to fill up with water. The colliery has been kept as a living memorial to the Welsh coal industry. More than 100,000 visitors come to Big Pit every year to descend the 300-foot shaft in the cage and experience a fascinating underground tour.

Location: SO 239088

Glyn Pits – One of the First Collieries to Use Steam-powered Winding Engines

Originally owned by the Hanbury family, this was one of the first pits to be sunk in this locality. The sinking was carried out by Capel Hanbury Leigh around 1840–45 to a depth of 190 yards. On one of the two stone buildings that remain on the site a plaque inscribed 'CHL (Capel Leigh Hanbury) 1845' can be seen.

The two stone engine houses both still contain their engines, which were made at the Neath Abbey Ironworks in 1845. This was one of the first coal mines in South Wales to use steam.

Inside the pumping engine house is a Cornish-type beam engine with the beam and the 17-foot wheel still in situ. The engine is a double-acting single cylinder with 24-inch bore and 6-foot stroke. It operated at 50 lbs of pressure and pumping was carried out in two stages, giving a delivery of 9,000 to 12,000 gallons per hour. The shaft depth is 186 metres and the pump delivered into a watercourse 85 metres from the surface. The water flowed to a lower surface level in the valley.

The vertical steam engine in the other stone building was in use until 1932, although the last recorded date of working coal here is 1928. Winding was carried out in two shafts at the same time. The engine is cased between four elegant, fluted Doric columns and high above are the winding wheels, each 15 feet in diameter.

In 1855, the Glyn Pits were acquired by the Ebbw Vale Company. When the company was reformed in 1891 as the Ebbw Vale Steel, Iron & Coal Co. Ltd, they sublet their Pontypool mineral estate, including the Glyn Pits, to James and William Wood, colliery proprietors of Glasgow.

The last recorded date of the colliery working is 1928 when it was owned by the Crumlin Valley Collieries Ltd, Pontypool, who also owned Hafodyrynys Colliery. It stopped operation in 1932 but was later used as a pumping station for Hafodyrynys Colliery. Modern pumping equipment was used instead of the old beam engine and was in operation until 1966 when

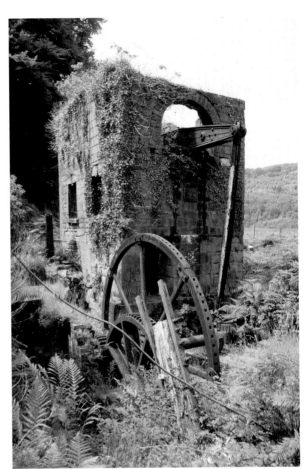

Right: This Cornish-type beam engine is still in situ at Glyn Pits, near Pontypool.

Below: The winding engine house at Glyn Pits was last used in 1928.

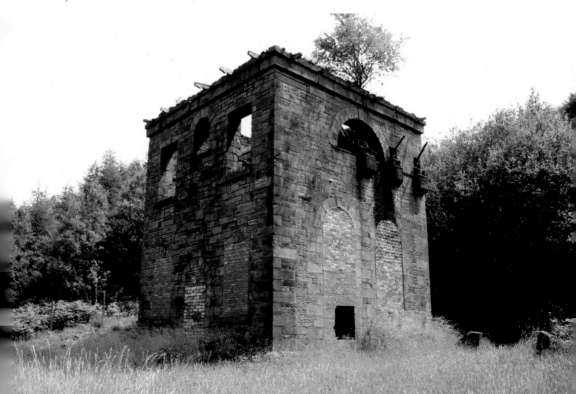

the NCB stopped pumping at Glyn Pits. The shafts were filled in, but the two engine houses and their machinery were left intact for future restoration.

The two engine houses are now fenced off by spiked galvanised steel for safety and to prevent parts of the engines being stolen. A corrugated roof has also been installed to protect the beam engine from the elements, but rain can still come in sideways.

In 1971, the National Museum of Wales drew up a plan to preserve these engines, but it was abandoned. Then in 1988 there was an ambitious plan by the county council to carry out extensive preservation and restoration work at an estimated cost of £950,000. It included landscaping, the provision of a new access road and car parking, but unfortunately nothing happened.

Location: ST 265999 – please note that there is no public access at present.

Cwmbyrgwm Balance Pit – The Last of its Kind to Stand on its Original Site

A water balance lift erected here in about 1820 was scheduled as an Ancient Monument, for it was the only surviving example of such pithead gear on its original site to be found in South Wales. Unfortunately, it was dismantled in the 1970s with a view to restoring it, but this never happened. Remains of the structure are scattered nearby and unfortunately some parts have been stolen. The oval-shaped brick-lined shaft is 104 yards deep and coal was raised by balancing a tram against a full tank of water, which was then emptied to reverse the process.

Higher up the hillside, an engine house chimney was connected with Cwmbyrgwm Colliery, which was started in 1840. This brick chimney built in 1888 is Grade II listed, being a rare example of a surviving colliery ventilation shaft. It is now in a dangerous condition with numerous bricks fallen out on its south facing side. The colliery closed in about 1900.

Location: ST 251033

Reconstruction of Cwmbyrgwm water balance lift. (MB)

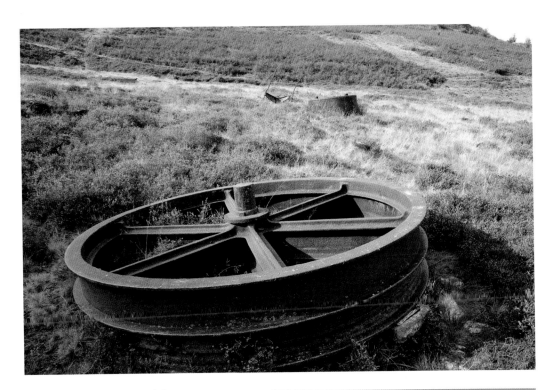

Above: Remnants of the structure are scattered around nearby.

Right: Brick ventilation chimney on the site of Cwmbyrgwm Colliery. (AMB)

Navigation Colliery – An Outstanding Set of Colliery Buildings

This is one of the best examples of Edwardian industrial architecture in the country, and one of the first collieries to be made completely out of brick rather than local stone with brick dressings. It was undoubtedly a show pit of the period with such high-quality buildings and modern machinery.

The shafts were sunk between 1907 and 1911 by Partridge, Jones & Company Ltd and shortly afterwards the mine was in full production. This firm was one of the largest coal combines in South Wales, owning nine collieries in the Monmouthshire Valleys.

By 1935 it was employing 358 men underground and eighty-six men on the surface. High-quality anthracite and steam coal was produced, which was needed for powering merchant and naval fleets. This explains the name 'Navigation' and denotes the high quality of the coal produced here.

In 1947, at the time of nationalisation, the colliery was taken over by the National Coal Board. Peak production was reached in 1954, with 145,129 tons of coal produced.

When this colliery closed in 1967 these very special buildings were preserved, and the site contains no less than eleven buildings listed Grade II and II*. These include two winding engine houses, colliery baths, fan house and fan drift, lamp room, colliery offices, powder store, pump house, workshops and stores.

It is now maintained and managed by the Friends of the Navigation, a team of dedicated volunteers who are restoring the site and buildings and bringing them into use for the community.

Location: ST 21159915

Navigation Colliery, Crumlin, has been preserved because of its architecture.

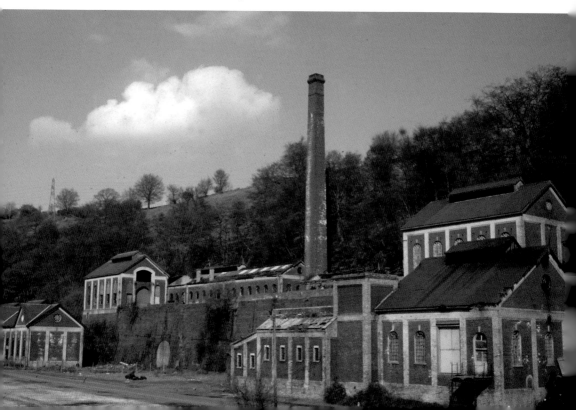

Colliery Disasters

The South Wales coalfield is probably the most famous in the world and it was one of the first to be worked with written records of coal extraction taking place in the twelfth century. However, the work was always hard and dangerous, and those who survived the inevitable explosions and roof falls usually became old before their time.

Major disasters had a variety of causes, including leaks of poisonous gases such as hydrogen sulphide, or explosive natural gases, especially methane (known as firedamp), flooding, and collapsing of mine slopes.

Llanerch Colliery – Suffered the Worst Mining Disaster in the Eastern Valley

This colliery was sunk in the parish of Trevethin, about 3 miles to the north of Pontypool, by the Ebbw Vale Company in 1858, initially to extract ironstone. Originally it was known as Cwm-nant-ddu, but the name changed when it was leased to Partridge, Jones & Co. Ltd in January 1887.

It consisted of two shafts 253 yards deep; the upcast shaft measured 16 feet by 11 feet and the downcast was 14 feet in diameter. The main seam worked was the 'Meadow Vein', which was 7 feet thick and worked by the pillar and stall system. The colliery had an annual output of over 7,000 tons of coal.

Ventilation was by means of a furnace at the bottom of the upcast shaft, which acted as a chimney, creating airflow through the workings and helped to prevent a build-up of dangerous gases. There was also the problem of carbon dioxide breathed out by men and pit ponies.

Firedamp could make it dangerous to have ventilation furnaces underground, so these were later replaced by large centrifugal fans driven by steam engines located on the surface

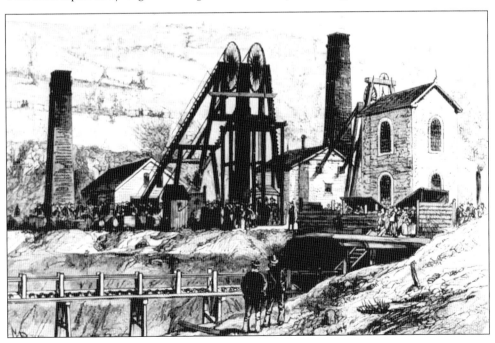

Llanerch Colliery at the time of the 1890 disaster. (*London Illustrated News*)

at the top of the mine shaft. This helped to remove firedamp, poisonous gases, caused by using explosives.

In October 1888, a Walker's patent fan, made by Walker Brothers of Wigan, was introduced, and the air to ventilate the workings went down to the face of Cook's slope and was prevented from entering the headings by means of doors placed at the entrances.

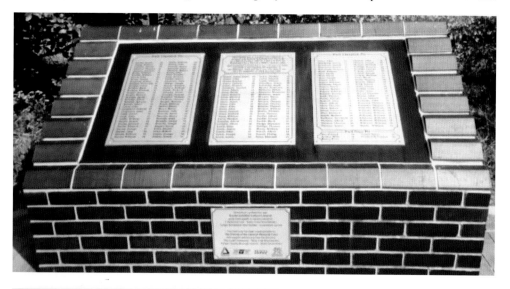

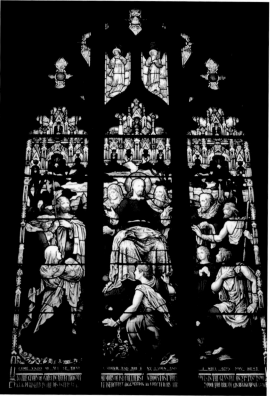

Above: Memorial to the victims of the 1890 Llanerch Colliery disaster.

Left: The first memorial relating to this disaster is a stained-glass window portraying Christ ministering to people in distress. It was installed in 1890 above the high altar in St Cadoc's Church, Trevethin (SO 283020), to commemorate the colliers who perished in the disaster at Llanerch Pit on 6 February 1890 and also five who lost their lives in Glyn Pit on 23 January 1890. A list of those who died can be seen near the choir stalls. The formal unveiling of this window by Mrs J. C. Hanbury took place on 3 November 1890.

On Thursday 6 February 1890, an explosion took place on Cook's Slope in which 176 men and boys lost their lives. The colliery closed in 1947 and no surface buildings remain on the site.

On the site of this long-demolished colliery, a black brick plinth in front of the former shaft bears a stainless steel plaque engraved with the names of those killed in the disaster. It also includes the names of five miners who died in an underground explosion at Glyn Pits, near Pontypool, two weeks earlier, on 23 January 1890.

Location: SO 252024

The Prince of Wales Colliery – The Third-worst Mining Disaster in Wales

About 12.15 p.m. on 11 September 1978 an explosion occurred at the Prince of Wales Colliery, Abercarn, which killed 268 men and boys. There were 358 who had begun that shift and only ninety survived. The Methodist Chapel lost half its members, and the local choir was reduced to one.

Of the 268 victims of this disaster, 138 were married, seventy were single and there were fifty-six youths and boys aged from thirteen years to eighteen. They left 528 dependents, 366 of whom were children. This was one of the greatest tragedies in the mining history of South Wales.

The rescue team managed to save ninety colliers, but only twelve bodies were recovered, because it was too dangerous to go any further and this meant that the rest of the bodies were left underground.

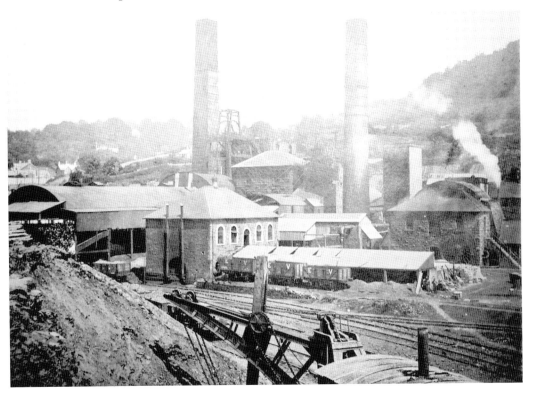

The Prince of Wales Colliery at Abercarn.

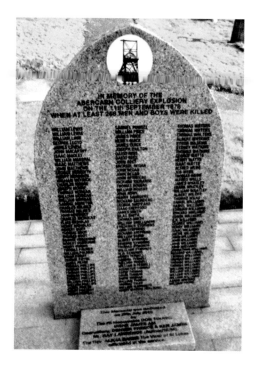

This memorial in Abercarn churchyard (ST 2295) to the 268 men and boys killed in the disaster was erected in September 2010, 192 years after this terrible event. Both faces of the stone are covered with the names of those who died.

During the next two months, water was redirected from the Monmouthshire Canal and about 35 million gallons poured down into the mine to extinguish the flames. The 2-mile shaft was then sealed and during the 1960s the site was cleared to make way for the Prince of Wales Industrial Estate.

The Six Bells Colliery Disaster – Commemorated by a Special Monument

This colliery, originally known as Arael Griffin, was built in 1863 by Thomas Phillip Price on the site of an earlier balance shaft. Then, in 1892, John Lancaster & Co. began sinking two 352-yard shafts, and by 1896 these were owned by Partridge Jones & Co., who employed 173 men to do the sinking and 101 on the surface. Coal winding began in 1898 and by 1914 there were 2,857 employed. This number dropped to 1,534 at the time of nationalisation in 1947. By 1960 the colliery was producing 338,000 tons of coal with 1,291 men employed.

Six Bells colliery and the nearby village takes its name from the Six Bells public house, but today it is best remembered for the tragic explosion on 28 June 1966 when forty-five men lost their lives. It was caused by an ignition of firedamp and coal dust in the air, which spread throughout the mine, killing forty-five out of the forty-eight men who worked there. The colliery was eventually closed by British Coal in March 1986 and demolished in 1989.

On the fiftieth anniversary of the explosion, *The Guardian* memorial statue was unveiled by Rowan Williams, the Archbishop of Canterbury, and the commemorative service was attended by 7,500 people from across the world.

Memorials to colliery disasters exist throughout the South Wales coalfield and while *The Guardian* commemorates those who died in the Six Bells disaster, it also serves as a memorial to all miners who have given their lives for coal.

Location: SO 218027

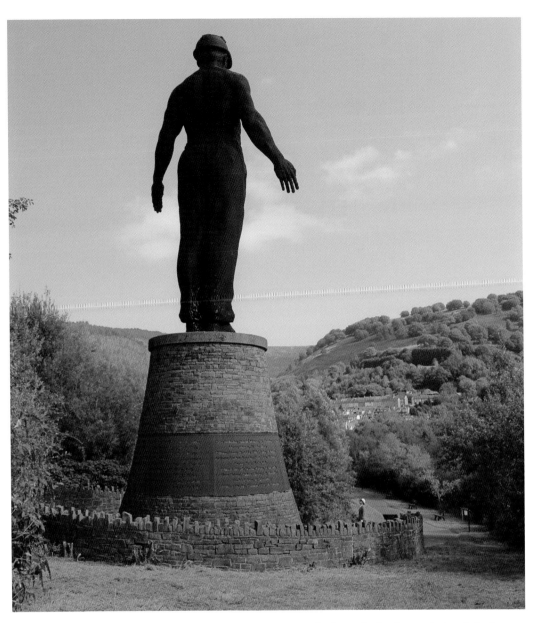

The Guardian of the Valleys is a 66-foot-tall statue overlooking the landscaped site of the former Six Bells Colliery, and was erected to commemorate men who died in the 1966 disaster. Designed and created by artist Sebastian Boyeson, it is made of over 20,000 strips of special weathering steel and appears to move or shimmer in the sunlight. The 41-foot-tall statue stands on a sandstone plinth 24 feet high and weighs around 8 tons. The names, ages and home towns of each of the forty-five victims can be seen on the steel plates surrounding the plinth.

6

The Monmouthshire Canal

An Act of Parliament passed in 1792 gave authority to the Monmouthshire Canal Company for 'making and maintaining a navigable canal from a place near Pontnewynydd into the River Usk, at or near the town of Newport and for constructing a collateral canal from the same, or near a place called Crindau Farm to Crumlin Bridge'. Under this Act the company were also empowered to construct railways within a distance of 8 miles from their canal.

Construction of the Monmouthshire Canal was needed for the purpose of transporting ironworks products to Newport Docks. The main promoters were Sir Charles Morgan of Tredegar House; William Esdaile, the London banker; Josiah Wedgewood, 1st Duke of Beaufort; and Thomas Hill, the Blaenavon ironmaster. The initial estimate of the cost of the canal construction was £108,000, but the final figure was nearer £220,000. It was built in two arms, which joined about a mile above Newport.

The complete canal system.

The construction of these two arms involved a combined rise of 793 feet and the associated construction of seventy-four locks, two tunnels and three aqueducts. By comparison the Brecknock & Abergavenny Canal only needed six locks, one aqueduct and a 375-yard tunnel.

Using just 'pick and shovel' methods the canal from Pontymoel to Newport was completed within three years, a feat that is still impressive even by comparison with modern civil engineering practice. An Act of 1797 allowed the canal to be extended below Newport to an inlet on the Usk known as Pillgwenlly.

The life of the canal was of course limited and in 1854 it was cut short by half a mile, with the result that it terminated at Canal Parade instead of Potter Street. Nine years later it was shortened again to finish at Llanarth Street. A further section was closed when the waterway was terminated at High Street Bridge, although a culvert still carried the water from this point to the Town Dock, until it too closed.

Canal building in this part of Wales was no easy task, because of the steep hills and deep valleys which were a difficult challenge for the surveyors and engineers, but the work involved created a considerable amount of employment involving thousands of labourers and skilled craftsmen.

Most of the labourers came from farms and villages in the area, but a good many also came from other parts of Wales such as Cardiganshire and Carmarthenshire. They were known as navigators or 'navvies' and their work was hard and dangerous with no compensation for injury or loss of life. The impact that such a large workforce had

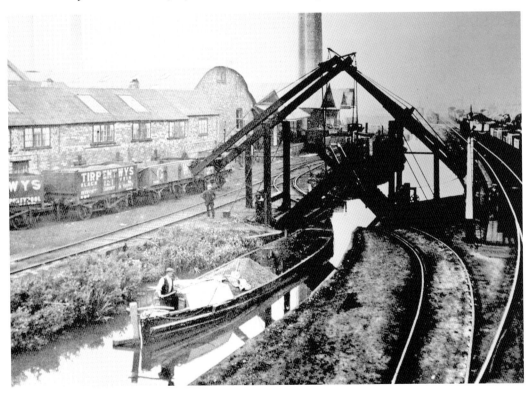

A narrowboat on the Monmouthshire Canal approaching Newport Docks.

on small rural communities was notorious, with incidents of theft, rape and murder quite common.

The main effect of the canals was to accelerate the progress of the Industrial Revolution but as working concerns they had quite a short life. It was not long before the railways quickly took over as the prime system of transport and by 1900 the waterways were carrying very little traffic at all.

The Crumlin Arm

This 11-mile branch of the Monmouthshire Canal ran from Crumlin in the Western Valley through to Rogerstone and then eastwards to meet the Eastern Valley branch at Crindau, just outside Newport. It was 11 miles long with a height difference of 32 feet to be negotiated, which involved 358 feet that required thirty-two locks. It was completed in 1798.

The engineer was Thomas Dadford Jr, who already had considerable experience in canal building, having previously assisted his father in the construction of the Glamorgan Canal. He started building the canal at Crumlin and continued southwards towards Newport.

Between Crindau and Crumlin, Thomas Dadford found it necessary to construct thirty-two locks. He built five at Allt yr Yn and fourteen at Cefn (Rogerstone). The building of this section of canal was a very difficult task, but, amazingly, it was completed in just three years.

Old postcard showing the staircase of fourteen locks near Rogerstone.

The Fourteen Locks – The Longest Flight of Canal Locks in Wales

The flight of fourteen locks at Rogerstone is a remarkable engineering achievement. The canal had to rise 168 feet within half a mile and a staircase of locks was the only answer to this problem. However, an additional consideration was that an enormous quantity of water would obviously be needed to fill every lock each time a narrowboat passed through. To fill a single lock took no less than 40,000 gallons of water.

Thomas Dadford decided to conserve water by building a series of balancing ponds alongside the fourteen locks. This meant that the water from the top lock could be drained into the first balancing pond and reused in the next lock below, and so on all the way down the staircase. Well, at least that was the theory, but the recycling of water never proved as efficient in practice, particularly in the summer when there were frequent water shortages.

The 'header' and 'side' ponds were designed to fill the top and lower locks respectively, using the same water twice whenever possible. Water would drain from the top locks into the side ponds, and this water would then fill the lower lock.

Location: ST 280885 (the Visitor Centre)

Situated beside the top pond is the Fourteen Locks Canal Visitor Centre, which was established in 1975 by Gwent County Council and Newport Borough Council. Inside is a fascinating exhibition on the history of the canal, a shop, café and toilets. It is now managed by the Monmouthshire, Brecon & Abergavenny Canals Trust.

Beyond the Fourteen Locks Centre is a 5-mile pound to Cwmcarn, above which twelve locks were needed at regular intervals to bring the waterway to Crumlin.

Today, the canal ends at Cwmcarn, for the A467 was constructed along the route of the canal in the late 1960s. During the canal era, Cwmcarn was the point where loads were transferred to the canal from the Aberbeeg and Beaufort tramways, which followed the two arms of the Ebbw to the ironworks at the heads of the valley.

At Cwmcarn the canal was supplied with additional water from a reservoir known as Roger's Pond. A serious incident took place here on 14 July 1875 when heavy rain caused the reservoir to burst its banks, sending thousands of tons of water cascading down into the Carne Valley. It enveloped a cottage occupied by the Davis family, who were all drowned, and made a breach in the canal embankment 40 yards wide.

The force of the water then continued to destroy a substantially built house that adjoined the local flannel factory. Eight members of the Hunt family who lived there were drowned, with the exception of Mr Hunt, who was washed into the branches of a tree. It was some hours before he was rescued, but he was so shocked and badly injured that he died soon afterwards.

The canal terminated about half a mile beyond the Navigation Inn at Crumlin and was slightly shortened when the Crumlin Viaduct was built, with one pier standing in the bed of the canal.

Today the Crumlin arm of the canal is just 8 miles long, having been truncated at Cwmcarn, some 3 miles short of its original destination at Crumlin. It was closed in 1949 and the eastern arm of the canal to Newport finally abandoned in 1962.

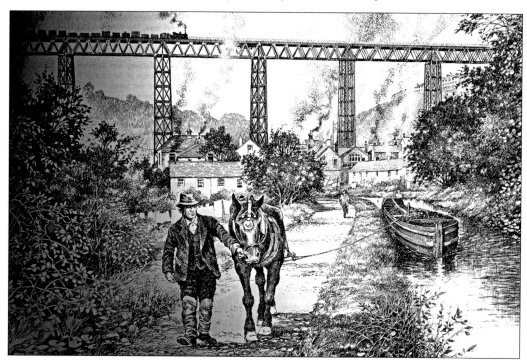

Beyond the Fourteen Locks Centre is a 5-mile pound to Cwmcarn, above which there were once twelve locks at regular intervals, bringing the waterway to Crumlin, where the famous Crumlin Viaduct was built. (MB)

Pen Y Fan Pond – The Best Example of a Canal Feeder Pond in Wales

Situated 1,000 feet above sea level and covering 14 acres, this man-made reservoir was built in 1794–96 to supply water to the Crumlin arm of the Monmouthshire Canal. It was formed by constructing a large earth dam with stone facings, forming banks on three sides of a gentle slope.

The outlet to the canal feeder led to a stone-lined channel and this 2-mile-long watercourse flowed down to the canal basin, which was situated about half a mile beyond the site of the later Crumlin Viaduct.

Above: Pen y Fan Pond was constructed to supply water to the Monmouthshire Canal.

Right: Stone-lined channel built to convey water from Pen y Fan Pond to the old canal basin at Crumlin.

Today, Pen y Fan Pond is owned by the local authority and is listed as an Ancient Monument under the care of Cadw. In 1976, it became a country park and is a popular attraction, particularly in summertime, when it is used for fishing, sailing and canoeing. There is also a footpath providing a walking route around the perimeter of the pond.

Location: ST 195005

Pontymoel Basin – The Junction of Two Canals

In 1812, the Monmouthshire Canal and the Brecknock & Abergavenny Canal were joined at Pontymoel to provide a complete waterway from Brecon to Newport. When the two canals were purchased by the Great Western Railway in 1880 they were renamed the Monmouthshire & Brecon Canal.

The junction cottage was constructed in 1814 for the Brecknock & Abergavenny Canal Company at a cost of £150 by William Jones, a Pontypool builder. Only the three-storey bow-shaped portion is original, the two-storey extension being added in 1824 at a cost of about £50.

The cottage was originally occupied by a water tender and his family. His main responsibility was the supervision of the lock gates, which were located to the front of the cottage. These were designed to restrict the movement of water from the Brecknock

Pontymoel Basin was the start of the Monmouthshire Canal.

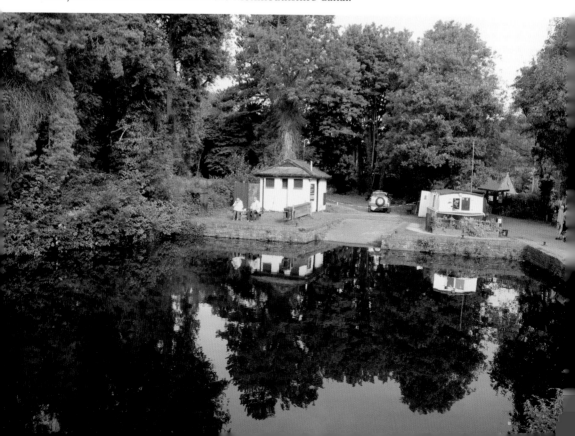

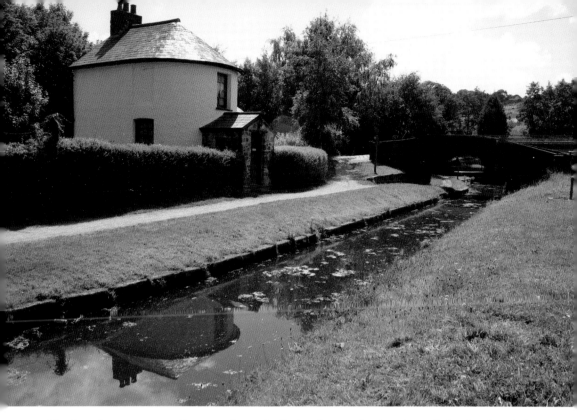

The junction cottage at Pontymoel was built in 1814 at the junction of the Brecknock & Abergavenny Canal and the Monmouthshire Canal for the purpose of collecting tolls. (AMB)

& Abergavenny Canal to the Monmouthshire, for each company jealously guarded their water supply. The lock gates have long gone, but the narrow lock chamber and the recess into which their open gates once sat can still be seen. The water tender also had the job of assessing the tolls due for the cargoes carried by the independent contractors who operated the narrowboats on the canal; such tolls were the canal company's main source of income.

The tolls were based on the weight of goods carried along each mile of the canal's length. The weight was calculated by the depth at which the narrowboat sat in the water, and referring this measurement to a displacement chart prepared when the narrowboat entered service. The weight indicated by this chart was then multiplied by the charge per ton per mile (between 1/2p and 2p) shown on the company's tariff, and the toll collected.

Boats would take a whole day to travel the 11 miles from Pontnewynydd to Newport and the Monmouthshire Canal was undoubtedly handicapped by the number of locks on this route. Also, the section of canal from Pontymoel to Pontnewynydd with its eleven locks was always short of water. Its abandonment was authorised under Acts of 1843 and 1848 but it was not closed until 1849.

Location: ST 294003

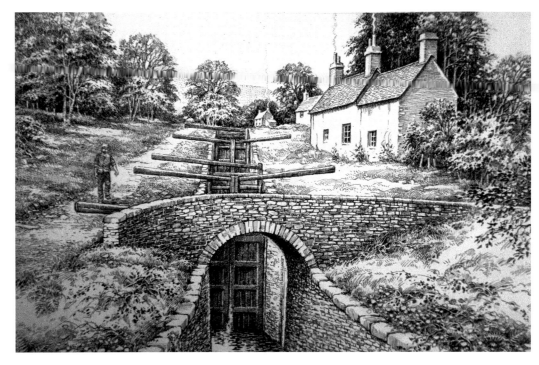

This branch of the Monmouthshire Canal led to Pontnewynydd and the height difference required eleven locks. It can no longer be seen, having been destroyed in the 1970s.

The Brecknock & Abergavenny Canal

Construction of this canal began in 1797 on the section from Gilwern to Brecon and Thomas Dadfor Jr was the engineer. It reached Brecon by 1800, which was a remarkable achievement in such a short time.

The southern section from Gilwern to Llanfoist was completed in 1805 by Thomas Cartwright and the final section joining the Brecknock & Abergavenny to the Monmouthshire Canal was built from Llanfoist to Pontymoile by William Crosley, who had previously been engineer for the Rochdale Canal. His instructions were to complete this new project within three years and he managed to achieve this target with assistance from John Hodgkinson, who surveyed the route down to Pontymoile. In today's terms it was almost the equivalent of building the Channel Tunnel.

Govilon Wharf – Always An Important Location

This was the terminus of the B&A Canal from 1805 to 1812, but in 1810 work restarted on extending the waterway to Pontymoel, near Pontypool. A three-storey warehouse was built by the Bailey brothers in about 1820, marking the end of their tramroad that had been constructed to bring iron from Nantyglo Ironworks and limestone from their quarries in the Clydach Gorge. The building was restored in 1980 and now serves as the regional office

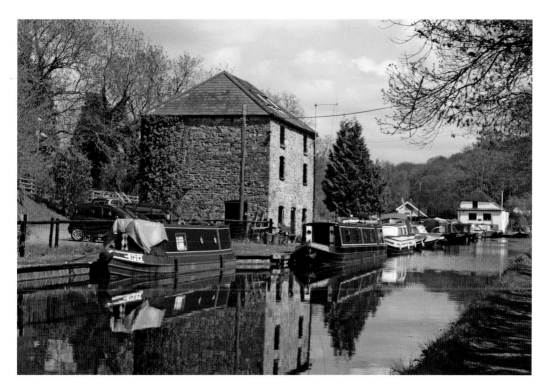

Govilon Wharf, with its three-storey warehouse, was built by the Bailey brothers in around 1820, marking the end of their tramroad, which brought iron, coal and limestone to the wharf.

of the Canal & River Trust, who are responsible for the Monmouthshire & Brecon Canal. The old wharfinger's house is now the headquarters of the Govilon Boat Club. Govilon Wharf was also the start of the horse-drawn Llanfihangel Railway connecting Abergavenny with Hereford.

Location: SO 271137

Llanfoist Wharf – Said to be the Most Picturesque Spot on this Canal

Llanfoist Wharf was originally known as Abergavenny Wharf and it became the termination of Hill's Tramroad, which was built in 1817–19 by the Blaenavon ironmaster Thomas Hill to connect his works, via Garnddyrys Forge, with the B&A Canal at Llanfoist. Here the trams were unloaded, and the iron products transferred to his warehouse. They were then taken on a two-day journey to Newport Docks. Limestone and coal was taken by narrowboat in the other direction to Brecon and also by tram from this wharf down an incline leading to limekilns and a coal yard in Llanfoist village. From there was a link with the Llanfihangel Tramroad.

The white cottage at the wharf is the old wharfinger's house, which was occupied by the manager, who earned £5 a year and was responsible for issuing loading permits.

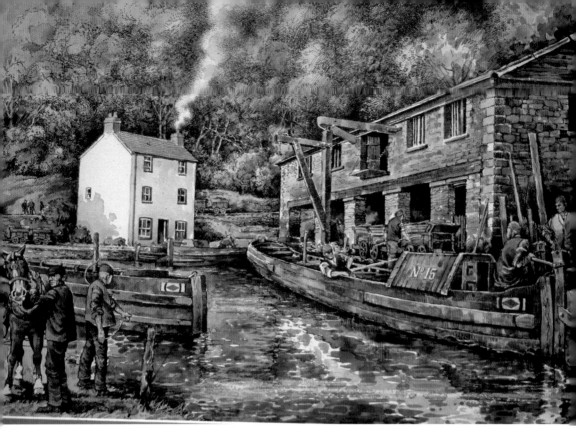

Llanfoist Wharf as it would have been in around 1840, and remarkably still looks very much the same today. (MB)

By 1860, Llanfoist Wharf was no longer used by the Blaenavon Ironworks Company, a railway having been constructed down the Eastern Valley to link Blaenavon with Newport.

Location: SO 234131 – please note there is no public parking at the wharf

Goytre Wharf – The Largest One on the B&A Canal

Goytre Wharf was built in 1810 with its impressive bank of limekilns to serve the Llanover area. The purpose was to develop the trade in coal and lime. Stables and workshops were also built and a weighing machine installed.

The wharf is the same level as the top of the kilns, which meant that coal and limestone could be brought to them straight from the canal. These kilns were very well built and are still in excellent condition. They were loaded from the top with successive layers of coal and limestone and filled right up. They were then fired from the bottom and the flames would rise up through the layers, burning the coal away and turning the limestone into a white powder, known as quicklime. When the kiln had cooled, the quicklime would be extracted from the bottom, loaded into barrels and taken away in carts. Before the carts went under the aqueduct they stopped at the weighbridge outside

Machine Cottage (now called Aqueduct Cottage) where the value of the lime or coal they carried was calculated.

Much of the lime manufactured in the kilns along the canal was for agricultural use, for when spread on the land it will neutralise excess acid in the soil and make the land more fertile and productive. Lime was also used in the making of mortar used for binding bricks and stones when building.

Location: SO 313064

Goytre Wharf is a popular attraction comprising a visitor centre, restaurant, aqueduct, limekilns and a busy marina where canoe and day boats can be hired from Red Line Boats. This illustration shows how the wharf would have looked in the nineteenth century. (MB)

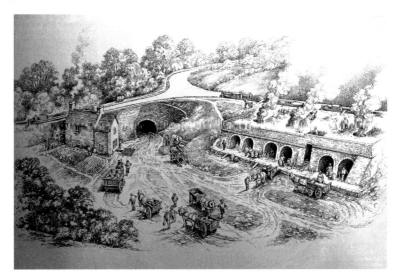

The impressive bank of limekilns at Goytre Wharf.

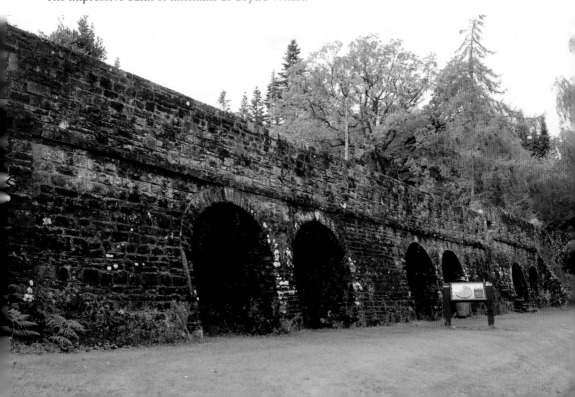

7

Railroads and Tramroads

Transport to the ironworks and then on to the coast was originally by packhorse, but this was obviously far too slow and costly for the expanding iron industry. One mule could carry 3 hundredweight (151 kilos) in panniers without difficulty and its working life was twenty-five years compared to twenty for a horse. Packhorses and mules operated in teams of twelve and the total load was known as 'a dozen'.

The Canal Act of 1793 also provided for the building of tramways from the canal to the ironworks, quarries and collieries within a distance from it of 8 miles; the wording was as follows:

> For making and maintaining a navigable cut or canal from, or from some place near, Pontnewynydd, into the River Usk at or near the town of Newport and for making and maintaining Rail Ways or Stone Roads from such Cuts or Canals to serve Iron Works and Mines in the County of Monmouthshire.

When the Monmouthshire Canal was completed in 1798 the situation was eased for a while, particularly when it was linked to the horse-drawn tramways to the various ironworks, collieries and quarries. These routes provided vital links and also enabled ironstone, coal and

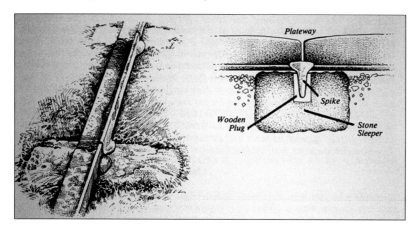

The plateways were fastened to stone sleepers by an iron spike driven into an oak plug.

limestone to be transported from their extraction sites to the ironworks. In due course they also provided connections with the collieries. The total mileage of tramways constructed in Monmouthshire under the Canal Acts between 1792 and 1830 amounted to 145 miles.

Various improvements which led to reducing the cost of producing iron rails resulted in an increase in the building of railroads. These were about 4 feet wide, the heavy rails being pegged down to long wooden sleepers, laid on large flat stones with holes drilled into them. Upon these rails ran bulky trolleys or waggons with box-like wooden bodies fitted with flanged iron wheels. They carried loads ranging from 1 to 6 tons and were pulled by mules, but on steep inclines the self-acting principle of a controlled descent by gravity was adopted. Their speed and the quantity of the material they carried was impressive.

In 1880, as a result of a recommendation from the engineer Benjamin Outram, the old rails were replaced with flanged iron plates and it was then no longer necessary for the waggons to have grooved rims on their wheels. These L-shaped plates known as plateways were laid on blocks of stone and fastened in place with iron spikes driven into oak plugs inserted in the block holes.

In 1791, not a single yard of railroad existed in South Wales, but between 1800 and 1830 several hundred miles were constructed. It would even have been possible to take the longest tramroad journey in the world, if one travelled from the head of the Monmouthshire Canal at Crumlin to Nantyglo, then on to Brynmawr, down Bailey's Tramroad to Govilon, and then on by the Llanfihangel Tramroad to Hereford – a total distance of nearly 100 miles.

Examples of Monmouthshire Tramroads

Bailey's Tramroad, completed in 1821, ran for 5 miles from the Nantyglo Ironworks down the Clydach Gorge to Govilon Wharf. In later years much of it was used for the Abergavenny to Brynmawr Railway.

Hill's Tramroad, completed in 1819, ran from Blaenavon Ironworks, through the Pwll Du Tunnel and on to Garnddyrys Forge, then around the north side of the Blorenge and down three inclies to reach Llanfoist Wharf on the B&A Canal. A fourth incline led down to the Llanfihangel Tramroad.

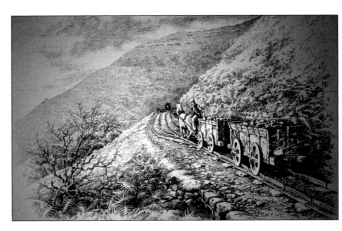

Hill's Tramroad near the top of the Llanfoist incline. (MB)

71

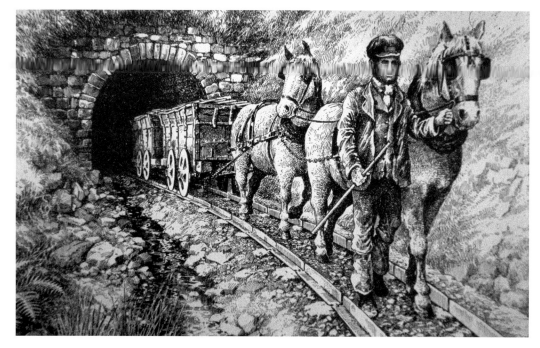

Pwlldu Tunnel, which was the longest horse-drawn tramroad tunnel in the world, enabled Hill's Tramroad to connect Blaenavon Ironworks with Garnddyrys Forge.

The Pwlldu Tunnel, 6,152 feet in length, was the longest horse-drawn tramroad tunnel to be built in Britain. It was originally a level extending 0.75 miles into the hillside from the Blaenavon end and was extended in 1816 to provide a route for Hill's Tramroad, which led to Garnddyrys Forge and the B&A Canal at Llanfoist.

Llanfihangel Tramroad started from Govilon Wharf on the B&A Canal and crossed the River Usk at Llanfoist and initially finished at Llanfihangel Crucorney. It finally reached Hereford in September 1829 when the first consignment of coal was delivered. In later years much of the tramroad between Abergavenny and Hereford was was used for the construction of the railway line to Hereford, which opened on 2 January 1854.

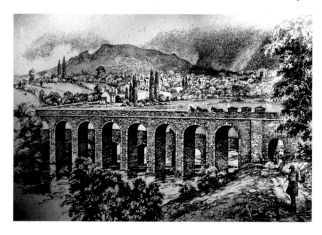

The Llanfihangel Tramroad bridge, which spanned the River Usk at Llanfoist. (MB)

8

An Impressive Network of Steam Railways

Canals and tramroads were slow methods of transport and really quite inadequate to meet the continuing rapid growth in industry, so the ironmasters and colliery owners began to think of railways, which were now made possible with the invention of the steam locomotive.

The age of the railway had been heralded as early as 1804, when Richard Trevethick's high-pressure tram engine locomotive became the first in the world to draw a load on rails This was the result of a wager, and it conveyed a load of 10 tons of bar iron for a distance of nearly 10 miles along the Penydarren Tramroad between Merthyr Tudful and Abercynon. It was twenty years before the time of George Stephenson's *Puffing Billy* and the opening of the Stockton & Darlington Railway.

In 1829, Samuel Homfray purchased a locomotive called *Britannia* from George Stephenson of *Rocket* fame, and in due course it made its first journey from Tredegar to Newport but initially had a few problems that had to be rectified.

A few days later *Britannia* hauled its first load of 57 tons of iron along this route. Travelling at an average speed of 6 miles an hour, it moved twice as fast as the tram horses and pulled double the load. Gradually the journeys were increased from two a week to a daily return trip with loads up to 70 tons, including coal, timber and an occasional tram of lime or fireclay.

Steam power certainly accelerated progress and the majority of railways were built during the two decades from 1850 to 1870. This led to an ever-increasing demand for iron, with the result that in the 1860s there were 165 furnaces in blast in Gwent producing a million tons of iron.

Gradually, all the tramroads were converted into railways with the exception of those with particularly steep gradients, where horse-drawn trams continued to be used. It was later claimed that 'no county in the kingdom was better off for railway communication than Monmouthshire'.

When the line from Brynmawr to Blaenavon was opened in 1869, Waunavon Station, at 1,400 feet above sea level, became the highest standard-gauge railway station in England and Wales. In order to reach this height the railway climbed severe gradients on each side of Waunavon, making it a very difficult line to operate and limiting the length of the trains.

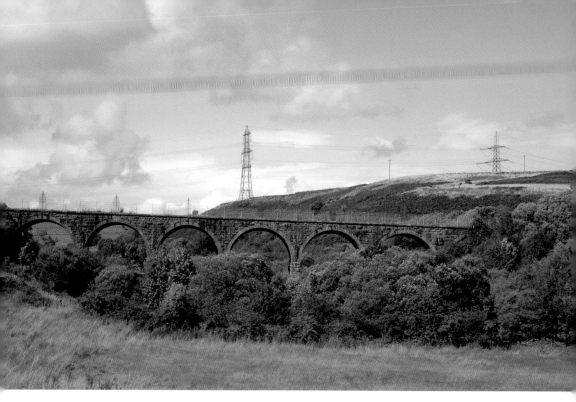

Blaen y Cwm Viaduct was built by John Gardner for the MT&A Railway. It was crossed by the last passenger train on 5 January 1958 and is now part of National Cycle Route 46.

Blaen y Cwm Viaduct – Once Carried the MT&A Railway

Also known as Nine Arches, this graceful 118-yard viaduct over the River Sirhowy to the north of Tredegar was built in 1864 to carry the Merthyr, Tredegar & Abergavenny Railway. It is well preserved, has been given a Grade II listing and is still in use as part of a national cycle route.

Location: SO 133109

Garndiffaith Viaduct – A Very Impressive Stone Railway Viaduct

Spanning the steep-sided valley of the Ffrwd at Garndiffaith, this stone viaduct was built by John Gardner, consultant engineer in this area to the London & North Westen Railway. It was constructed to carry the LNWR at the southern end of their Blaenavon branch, off the Merthyr, Tredegar & Abergavenny line, to meet the Talywain branch of the Monmouthshire Railway & Canal Company (GWR from 1880).

Nine semicircular arches were built of equal sections of three arches, following a gentle curve, with the viaduct narrowing towards the east end. It is a Grade II listed monument

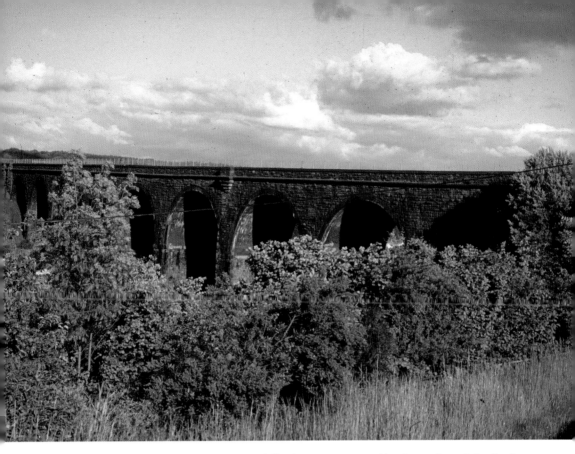

This impressive, nine-arch viaduct at Garndiffaith was constructed by the engineer John Gardner in 1878.

and most impressive when seen from higher up the valley. It opened for passenger traffic on 1 May 1878 and also served the collieries and ironworks in the Abersychan area. The line closed in 1965 and is now a cycle track.

Location: ST 263042

Clydach Viaduct – Built on a Gentle Curve for the MT&A Railway

This impressive stone viaduct was built by John Gardner, near Clydach station, to carry the Merthyr, Tredegar & Abergavenny Railway. It is 312 feet long, 26 feet wide, constructed with a graceful curve and supported by eight semicircular arches, each of 30 feet span.

From Cwm Dyar, below the viaduct, one can look up at this great structure and see the projections from the piers, which supported the wooden structure upon which the arches were constructed. It is also possible to see how the viaduct was widened on the upper side when the line was doubled in 1877.

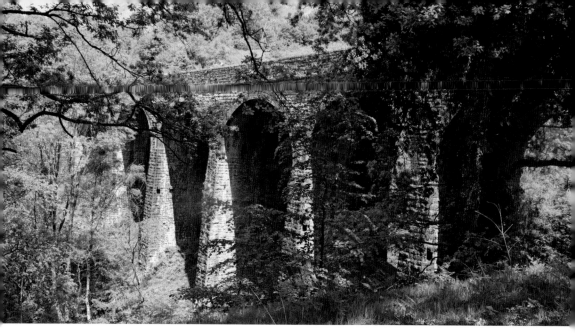

From Cwm Dyar, below the viaduct, one can look up at this great structure and see the projections from the piers, which supported the wooden structure upon which the arches were constructed. It is also possible to see how the viaduct was widened on the upper side when the line was doubled in 1877.

Abergavenny Station – An Ex-GWR Station Still in Regular Use

In January 1857, the Newport & Hereford Company opened their line from Newport to Abergavenny and Hereford. The Newport, Abergavenny & Hereford Railway amalgamated with other railways in 1860 to form the West Midland Railway, which in due course amalgamated with the GWR in 1863.

Abergavenny station was built in 1857.

Known as Monmouth Road, this ex-GWR station was designed by Charles Liddel in an Italianate architectural style. It is Grade II listed and still in use, being on the main line to Crewe.

Location: SO 305136

Chepstow Railway Station – Built By Isambard Kingdom Brunel

Constructed in 1850, this is one of the few original remaining stations designed by Isambard Kingdom Brunel. The platforms are very far apart, having been built for his Great Western Railway, which initially used the 7-foot broad gauge, but later changed to George Stephenson's standard gauge of 4 feet 8 and a half inches.

In 1872, Brunel's broad-gauge tracks were replaced with standard gauge and there were complaints about the gap between the trains and the platforms, so the platforms were raised. In 1857, the station building, weighing about 150 tons, was also raised.

Access to one of the platforms is via a cast-iron footbridge, which is a rare survival of a typical GWR platform footbridge with wooden cladding and canopy (now corrugated iron). Grade II listed, it was cast in Edward Finch's works, adjoining the station, in 1892.

Location: ST 536936

Chepstow railway station was built by Brunel in 1850.

The Old Station Tintern – A Preserved Victorian Country Railway Station

Railways have come and gone and one of the much-regretted closures during the infamous Beeching era was the Wye Valley line, which opened in November 1876. For more than seventy years, locomotive Nos 6431, 6417 and 3726 steamed up and down the valley, drawing waggons laden with iron ore, brass fittings, and even barrels of cider produced on outlying farms.

In addition, a passenger service of four trains in each direction per day brought many visitors to admire the beauty of the valley. The 14-mile journey from Chepstow to Monmouth would take 45–50 minutes with stops at eight halts and four stations. Although the train stopped twelve times during the journey, it was only at Tintern station that two trains were able to pass one another. The single track pursued a sinuous course, keeping close to the river all the way, crossing it several times and rewarding the passengers with excellent views.

Sadly, the railway never made a profit and its losses were blamed on various factors, such as bad weather affecting the tourist trade, and the closure of manufacturing industries, which in fact had been in decline for years before the construction of the line. There were also disagreements between the Great Western Railway who operated the line and the Wye Valley Railway who owned it.

By 1958 the line was losing more than £20,000 a year and when the decision was made to abandon passenger traffic, it was officially closed for this service on 5 January 1959. Goods traffic continued, but even that was finally withdrawn in January 1964. The rails were sold for scrap and the bridge over the Wye at Tintern was demolished.

Tintern Old Station is now a popular visitor centre and picnic site with a tea shop in the original waiting room.

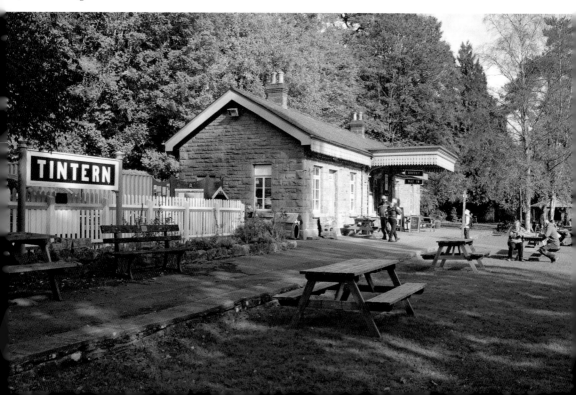

The old signal box has also been restored.

In 1974, the station was purchased by Gwent County Council and the station building and signal box restored. The site was opened to the public in September 1975, 100 years after the first train made the journey from Chepstow to Monmouth. This was the beginning of a new era in the life of the station for it soon became a popular visitor centre where people come to enjoy a picnic and learn about the story of the Wye Valley Railway.

Today, it is owned and managed as a countryside Visitor Centre by Monmouthshire County Council. This fine example of a Victorian country railway station was once the largest station on the Wye Valley line between Chepstow and Monmouth

Location: ST 536006

Stow Hill Railway Tunnel – Built By Isambard Kingdom Brunel

The Stow Hill railway tunnel at Newport was engineered by Isambard Kingdom Brunel for the South Wales Railway, which was one of the most important of the early routes into Wales. The first train to pass through the tunnel was on 18 June 1850.

It takes the railway line under Stow Hill from a point south of Newport station and emerges 742 yards away near Llandaff Street. The contractors were Messrs Rennie and Logan, who employed 400 men and fifty horses on this project.

Stow Hill railway tunnel was engineered by Brunel in 1850.

It consists of a pair of semicircular bores of approximately 680 metres in length. The earliest East Bore dates from the construction of the line in 1846–50 and is Grade II listed. The parallel West Bore dates from 1911 and was built in order to double the track. The interior of both tunnels is faced in stone. The two portals are different in design. The one which was opened in 1848 as a broad-gauge route was built by the South Wales Railway and sponsored by the Great Western Railway. The other one was built in 1910 on the north side in order to widen the route to four tracks.

Location: ST 305875 (the portal just south of Newport station)

The Severn Tunnel – Once the Longest Railway Tunnel in the World

A proposal to build a railway tunnel underneath the River Severn was originally put forward by Charles Richardson, once a pupil of Isambard Kingdom Brunel. The Parliamentary Act for the construction of the tunnel by the Great Western Railway was passed on 27 June 1872 and preliminary work was started the following year at Sudbrook when a trial shaft was sunk and excavations under the river were carried out and similar work in 1879 was undertaken on the other side of the river.

Construction of the actual tunnel was commenced in 1880 by Thomas Andrew Walker, whose tender for the contract was the only one received. Under the direction of Sir John Hawkshaw, the tunnel was completed in 1886 at a cost of £1,806,248.

The total length, including the approaches, is about 7 miles and, ignoring the London Underground railways, the Severn Tunnel is the longest railway tunnel in the British Isles. It has been described as 'the greatest undertaking, which the engineering skill of man has ever accomplished'.

The average number of men engaged in the work at the same time was over 3,000, and a complete village was built at Sudbrook in 1877 for this workforce and their families, with a school, mission hall, two hospitals, a coffee house and reading room.

No less than 76,400,000 bricks were used in the tunnel's construction and more than a third were made on site. It is lined throughout with brickwork 3 feet thick and is 24 feet high with a width of 26 feet.

The difficulties in building the tunnel were increased when the 'Great Spring' was exposed, which flooded the workings – even now about 20 million gallons of water a day flows into the tunnel and has to be pumped out. To give an idea of the immensity of such a quantity of water, it was sufficient at that time to supply a town the size of Manchester. In one year it would form a lake of about 1,000 acres in extent and 30 feet deep.

The tunnel proper measures 4 miles 624 yards and it lies 50 feet below the bed of the channel at its deepest part and is 145 feet under the level of high water at spring tide.

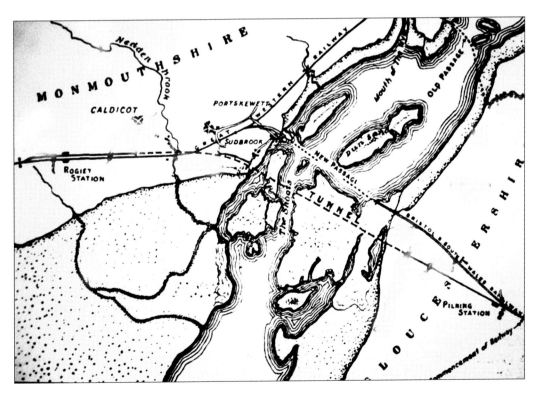

Route of the Severn Tunnel.

The gradient commences at Caldicot and the line passes below water at Sudbrook and continues through sandstone rock.

It was opened for goods traffic on 1 September 1886 and the first passenger train from London to South Wales passed through on 1 July 1887. Previously, passengers had to cross the Severn near Portskewett in a steam ferry boat or make a long carriage journey by road via Gloucester.

At Sudbrook on the Monmouthshire side of the Severn is a large, red-brick pumping station (built in 1886), which removes an enormous amount of spring water every day to prevent flooding in the tunnel. Originally this was done by six large Cornish pumping engines, powered by steam engines, until they were scrapped in 1968 and replaced by electric motors. This used to be the largest still fully functioning steam-powered pumping station in the world. Today, there are a total of fourteen pumps and four ventilation fans.

The Sudbrook pumping station, built in 1886, is heavily protected against sabotage.

For more than 100 years the Severn Tunnel was the longest underwater tunnel in the world until it was exceeded in 1987 by the Seikon Tunnel in Japan, which connects the Aomori Prefecture on Honshu Island and the Hokkaido Island and is 14 miles long.

The Tunnel Visitor Centre, situated in the Sudbrook Non-Political Club, tells the story of how this village was built in the 1870s to house the 3,000 workers constructing the Severn Tunnel.

Location: ST 505874

Blaenavon Heritage Railway – The Highest Standard-gauge Railway in Wales

This railway line opened in 1888 and was operated initially by the London & North Western Railway, then later by the London Midland & Scottish Railway. It is the highest standard-gauge preserved line in the country with a steeper continuous gradient than any other line. Trains are predominately steam-hauled, but certain services run with diesel engines or diesel multiple units.

Completely run by volunteers, this Steam Railway Society provides its members the opportunity to train and act as drivers, guards, station sales and refreshment staff. Other members are involved with restoration of locomotives, coaches and the track itself.

Trains run from 11.30 a.m. until 4.30 p.m. every Sunday and bank holiday.

Location: SO 235094

Blaenavon Heritage Railway is run by volunteers.

9

Cast-iron Bridges and Stone Viaducts

The first iron bridge in the world was built at Coalbrookdale in Shropshire in 1777–80 by Abraham Darby III and it inspired the construction of similar structures, particularly when it was seen how the Coalbrookdale bridge survived a great flood in 1795, which had severely damaged every other bridge over the River Severn.

Today, the Coalbrookdale Iron Bridge is Britain's best-known industrial monument and a tribute to the skill and daring of the eighteenth-century Shropshire ironmasters. It is probably the only eighteenth-century iron bridge that remains intact.

The first iron bridge in the world: Ironbridge, Shropshire, built by Abraham Darby III in 1777–80.

Chepstow Bridge – The Finest Georgian Regency Arch Bridge in Britain

This elegant, cast-iron bridge was designed by John Urpeth Rastrick of Bridgnorth, who modified an earlier design by John Rennie, the engineer who built Waterloo Bridge in London. He had estimated a cost of £41,890 for a bridge at Chepstow, which was considered too expensive. Rastrick offered to build the bridge for £17,150, so he won the contract. The final cost was actually £20,000, but this was still less than half of Rennie's estimate.

It was built by the Bridgnorth firm of Hazeldine, Rastrick & Co. in 1816 to replace an earlier wooden bridge that provided a vitally important link between South Wales and the south-west of England. It crosses a river that has one of the highest tidal ranges in the world and is Grade I listed. Made of cast iron in five arches, it has a centre span of 112 feet, intermediate spans of 69 feet, and outer spans of 33 feet. The bridge was opened on 24 July 1816 with an elaborate ceremony.

The style of the bridge was inspired by the work of Thomas Telford and today it is the largest iron arch bridge remaining from the first half century of iron and steel construction, before the invention of suspension bridges.

In 1984, it was superseded, except for local traffic, by the inner relief road bridge, which was built to take the A48 traffic across the river further downstream. Prior to that all road traffic to and from Gloucestershire had to pass through the narrow town arch and over the old cast-iron bridge.

Celebrations to mark 200 years since the opening of this bridge took place on 24 July 2016. Around 1,000 people turned out to watch a procession through Chepstow and the original opening ceremony was re-enacted on the bridge.

Location: ST 536944

The elegant cast-iron bridge at Chepstow.

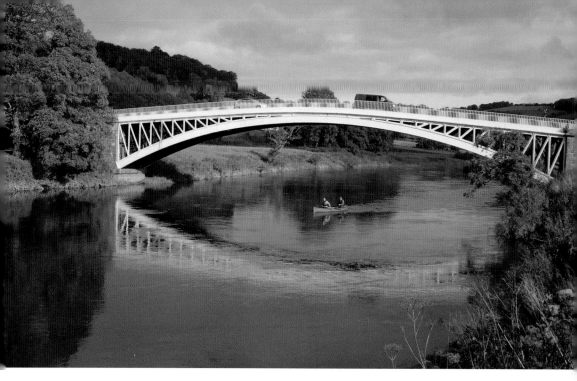

Bigsweir Bridge was built in 1827 across the River Wye.

Bigsweir Bridge – Said to be the Most Elegant Cast-iron Bridge in Wales

This single-arch, cast-iron road bridge was built in 1827 by Charles Hollis, the designer of Windsor Bridge, as part of the new turnpike road constructed up the Wye Valley between Chepstow and Monmouth. Cast at Merthyr Tydful, it gracefully spans the river and connects two counties and two countries. The old toll house is still standing, but no longer in use. Because of the narrow width of the bridge, modern traffic using the A466 is controlled by traffic signals at either end.

Location: SO 539051

Smart's Bridge – Built to Provide Access to Clydach Ironworks

Constructed in 1824, this bridge was built over the River Clydach to link Clydach Ironworks with the offices of the Clydach Ironworks Company, which stood on the other side of the river. They were demolished when the A465 (Heads of the Valleys Road) was first constructed.

 This early iron bridge was restored in 1986 by the team involved in the excavation and conservation of the Clydach Ironworks. The bridge was totally dismantled, treated with oxalic acid (a rust inhibiter) and reassembled. One of the end plates had been fractured so it was replaced by a new one cast in Abertillery. The entire structure was then painted with

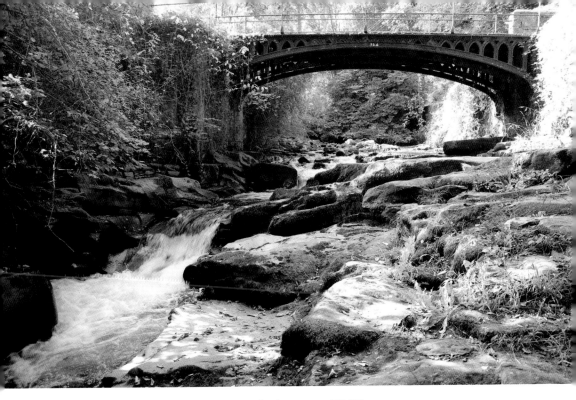

Smart's Bridge in the Clydach Gorge was built in 1924. (AMB)

bitumastic paint and new railings were recreated in a similar style to the railings that were known to have been on the bridge in the 1950s. Stone walls were then erected on each bank to hold the terminations of the hand rails.

Location: SO 229132

Brunel's Tubular Railway Bridge – The First Iron Bridge Built by Brunel

The Great Western Railway from London to Gloucester was completed in 1845 and the South Wales Railway Company was then formed to finish the route via Newport and Cardiff to Milford Haven, but in order to complete the line Isambard Kingdom Brunel had to design a bridge to cross the River Wye. The problem was complicated by Admiralty constraints requesting a navigable opening 300 feet wide with head room of over 50 feet at high tide. This was necessary because at that time the Wye was navigable up to Brockweir by vessels of 60 tons and by barges of 40 tons as far as Monmouth.

There was poor ground on the Chepstow side, so Brunel had to provide firm foundations, and this was done by sinking a pair of elevated wrought-iron tubes, side by side, supported at one end upon a tower. This rests upon cast-iron cylinders, sunk, using compressed air, to an average depth of 48 feet through clay, quicksand and marl to be embedded on solid limestone rock.

87

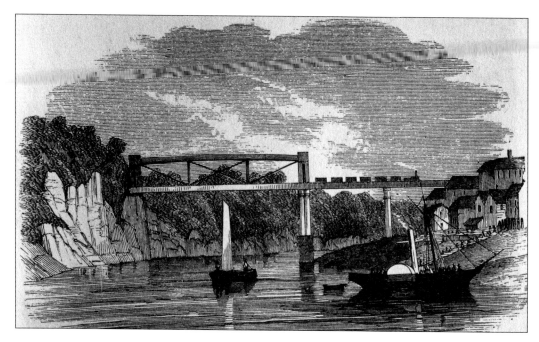

A unique tubular railway bridge spanning the River Wye at Chepstow was built in 1852 by Brunel.

Before this bridge was built the South Wales Railway ended on each side of the river and passengers had to make a connection between the two sections by travelling in a stage coach over the Wye road bridge. Brunel's much needed bridge enabled this gap to be filled.

Work began in 1849 and sections of the bridge were brought to the site by rail and sea. The bridge was built at a cost of £65,420 and a single line was formally opened on 19 July 1852. The first passenger train to pass over it was the 6.15 p.m. from Swansea. A second line was opened on 18 April the following year.

In 1962, Brunel's Bridge was dismantled and rebuilt to make it stronger.

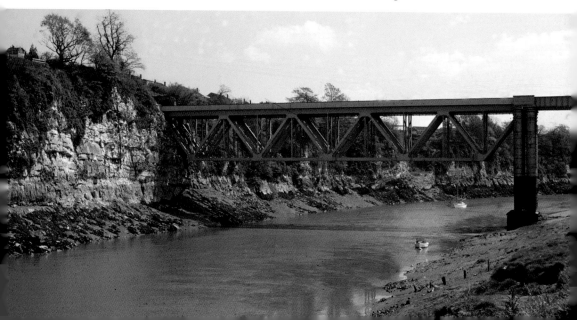

In 1962 it was decided that Brunel's tubular railway bridge was not strong enough to carry today's heavy trains, so it was dismantled and replaced by an underslung girder bridge.

Location: ST 539941

Crumlin Viaduct – Once the Longest and Highest Railway Viaduct in Britain

An Act of Parliament was approved on 3 August 1846 for the construction of the Taff Vale Extension, which would connect the Coedygric North Junction at Pontypool with the Taff Vale Railway at Quaker's Yard

In order to complete this line, the most difficult problem confronting the railway engineers was at Crumlin where it would be necessary to cross the wide Ebbw Valley and the smaller Kendon Valley. At that time the line ended at High Level station, Crumlin, which was faced by another terminus on the opposite side of the valley

A proposal to build a viaduct spanning these valleys at Crumlin was conceived by the Newport, Hereford & Abergavenny Railway and a contract was awarded to T. W. Kennard & Sons in 1853. Their first action was to establish a works at the eastern end of the viaduct site. It became known as the 'Nut and Bolt Works' and it remained in operation for a period of fifty-eight years. An inclined plane was also constructed to enable the ironwork to be taken down to the valley floor.

Preparations were then made to erect the first pier. They drained and excavated the canal near the basin to the north of the viaduct site and laid a foundation at a depth of 14 feet. It consisted of 1 foot of concrete, a course of 4-inch Memel timbers and a 12-foot course of masonry to which the baseplates were bolted.

This part of the structure became known as the Isabella Pier, being named after Lady Isabella Fitzmaurice, who took part in a stone laying ceremony here on 8 December 1853. A casket of new coins of this date was placed in the foundations and she celebrated the erection of the first piece of ironwork by breaking a bottle of wine over it. The watching workmen gave a loud and hearty cheer.

Horizontal girders, 150 feet in length, were fabricated on the floor of the valley and lifted into position by a steam winch. A gang of twenty men took a whole day to lift one girder to the highest point of the viaduct, rising above the valley floor at the rate of 4 inches per minute. The last girder was lifted into place on 17 December 1855. Decking was then laid, consisting of 6-inch Memel timbers in 26 feet lengths.

Before the viaduct could be opened it had to be tested in the presence of Colonel Wynne, Board of Trade inspector. The London & North Western Railway provided six tank engines, which were coupled together with a waggon load of pig iron, making a total weight of 380 tons. A volunteer driver then had to be found with the necessary courage to make the crossing. John Thomas Jenkins, a Pontypool locomotive driver known by his friends as 'Mad Jack', came forward and he was instructed to drive the train at crawling speed across the viaduct, to avoid exposing it to any early or unnatural strains.

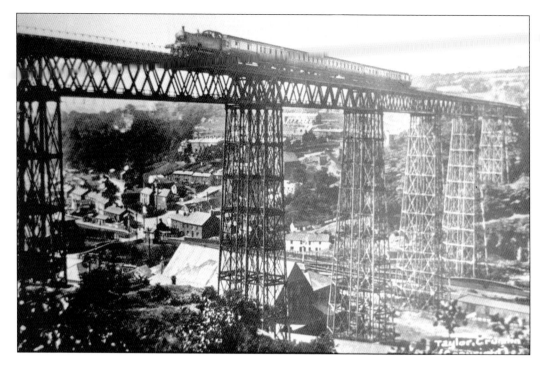

Train crossing the Crumin Viaduct, which opened in 1857 and was demolished in 1966.

The official opening by Lady Isabella Fitzmaurice was held on Whit Monday, 1 June 1857. It was a grand occasion which attracted a large crowd, the majority of which were labourers with their wives and children. The viaduct was draped with flags from top to bottom and as a tribute to the contractor a floral archway was set up bearing the words 'Long life and prosperity to T W Kennard'.

Not only was it the longest railway bridge in the world, but the highest in Britain and the third highest in the world. Also, it was the least expensive bridge for its size that had ever been constructed and even regarded as one of the 'wonders of the world' for engineering feats of this magnitude were rare.

It was 1,658 feet long and 208 feet high from the valley floor to the top of the handrails. To build it, 200 men had taken just four and a half years. The materials in its construction included 2,500 tons of iron, 30,000 cubic feet of timber and 11,000 cubic feet of ashlar masonry. The total cost was £62,000. 15 tons of paint were used to protect the metalwork and it was repainted by contractors at intervals of five to seven years.

During the 1930s there was concern over the possibility of the viaduct's stability being affected by mining subsidence. As a result the viaduct section was converted to single line, the track being placed in the centre of the structure and an electric token system installed between Crumlin Junction and Crumlin High Level station.

When the line closed under the Beeching axe, the last scheduled passenger train to cross the viaduct was the 9.10 p.m. from Neath to Pontypool Road on Saturday 13 June 1964. During the following year the now disused viaduct was used as a set for the film *Arabesque*, which included a dramatic sequence that showed Gregory Peck and Sophia Loren running along the walkway and being dive bombed by a helicopter.

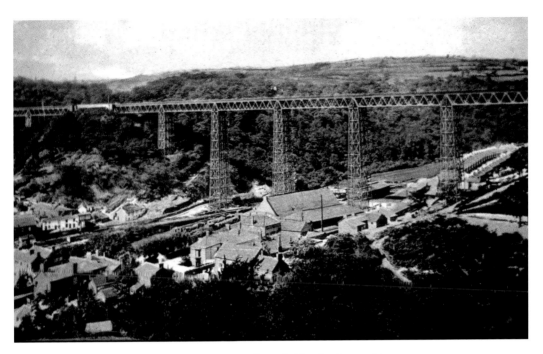

Crumlin Viaduct was once the longest railway bridge in the world.

In 1962, the viaduct was scheduled by the Ministry of Housing and Local Government as being of architectural and historic interest, but British Railways decided that demolition of the structure was the best course of action. It was estimated that the metal in the viaduct, based on scrap value of £15 per ton, would bring in £38,250.

Demolition was carried out by Messrs Birds of Swansea, who specialised in tearing down steelworks, various industrial undertakings and bridges that have had their day. The work was programmed to take nine months and was supervised by Brian Houston Barron. His biggest problem was the wind, which at times proved very troublesome.

Protected by safety harnesses, the demolition team methodically made progress and piece by piece dismantled the eight piers that supported the bridge structure. It was a difficult and dangerous operation, but they completed the job in June 1966 and the great Crumlin Viaduct became just a memory.

Location: ST 213985

Newport Transporter Bridge – One of Two of its Kind in Britain Still Working

In Newport the skyline is dominated by the town's famous Transporter Bridge, which is a landmark that can be seen for 20 miles or more from both sides of the Bristol Channel. The town (now a city) lay on both sides of the River Usk, and when works were built in Corporation Road and the Somerton areas, it was decided that a bridge was needed to enable workers to cross the water without having to a long way around via the main bridge.

The town council decided to employ the French engineer Ferdinand Arnodin to design a bridge similar to his 'Transbordeur', which had been erected at Rouen. Consisting of an aerial ferry, it would be free from the navigational difficulties associated with floating ferries and would also prove less expensive to build than a conventional bridge. Robert H. Haynes, the borough engineer, and Ferdinand Arnodin were appointed joint engineers; the scheme was sanctioned by Parliament in 1900 and work began two years later.

The bridge was built at a cost of £98,000 and officially opened, on 12 September 1906, by Lord Tredegar in the presence of the mayor (Councillor Liscombe), members of the corporation, and about 600 invited guests. Thousands of spectators occupied every vantage point from which a view of the proceedings might be obtained.

Each latticework tower is 245 feet high and the bridge has a span of 645 feet. The cross-section supports a travelling frame that is driven by electricity. From it, suspended by twenty-seven steel wires, is a travelling platform, 33 feet in length and 40 feet wide, on which vehicles and passengers are transported from one side of the river to the other at a speed of 5 miles an hour. Powered from an engine room on the east side of the river, it takes about one and a half minutes to complete the crossing and a load of 113 tons can be carried.

The travelling platform is capable of carrying up to 13 tons and itself weighs 27 tons. It is popularly referred to as the gondala and has been described as being like a small summer pavilion and resembling something like a Victorian bandstand and a wedding cake.

The people of Newport are proud of their Transporter Bridge and it has been awarded Grade I listed status in recognition of its architectural significance. It has also become a major tourist attraction that helps to put the city of Newport on the map.

There is a small visitor centre on the town side of the river where the story of this remarkable structure is told. This is one of fifteen transporter bridges in the world,

Newport Transporter Bridge is an iconic symbol of Newport's industrial past.

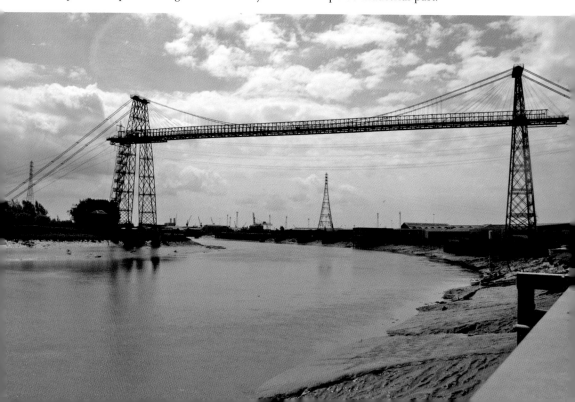

but the only other one still working is in Spain. There is also a transporter bridge at Middlesborough in North Yorkshire, but this is no longer in use.

Years ago, the charge for riding on the suspended carriage was one penny, but in due course this fee was removed. To walk along the top of the bridge cost 6*d*. Today, at the time of writing, the charges are: Cars £1 per crossing, and foot passengers and cyclists 50p per crossing. Day visitors (including access to motor house and high-level walkway) £2.50.

Location: ST 318863

The Two Severn Bridges – Modern, Iconic Twentieth-century Feats of Civil Engineering

The first Severn Bridge (Pont Hafren) was built to carry the M4 (now the M48) across the River Severn, thus linking England and Wales. It took five years to build, has a span of 3,240 feet and cost £8 million. A shallow steel box is used for the deck, which is shaped aerodynamically to allow wind to pass over and under it.

The bridge was opened by Elizabeth II on September 1966.

Location: ST 559902

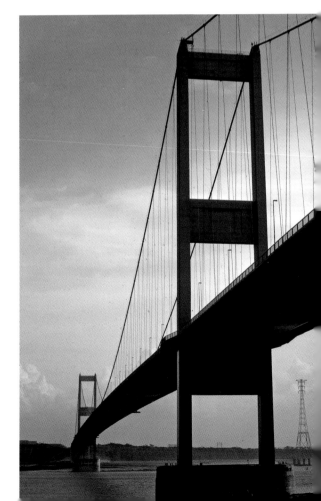

The first Severn Bridge was opened in 1966.

The second Severn Bridge was opened in 1966.

The second Severn Crossing (now called the Prince of Wales Bridge) was built 3 miles downstream from the first one in the 1990s by an Anglo-French consortium at a cost of half a billion pounds. A special feature is that the traffic is protected from high winds by wind shielding.

It took four years to complete and was formally opened by the Prince of Wales on 5 June 1996. It was officially named after him on 17 December 2018. This is now the main strategic route between south-west England and South Wales. Toll charges were removed totally from both bridges on 17 December 2018.

Location: ST 510866

Museums and Visitor Centres

Abbey Mill, Tintern: 01291 689228, www.abbeymill.com
Abertillery and District Museum: 01495 211140, www.abertilleryanddistrictmuseum.org.uk
Bedwellty House, Tredegar: 01495 353370, www bedwelltyhouseand park.co.uk
Blaenavon Heritage Railway: 01495 792263, www.pbrlwy.co.uk
Blaina Heritage Centre: 01495 292025, www.blaina.moonfruit.com
Big Pit National Coal Museum: 029 2057 3650, www museum.wales/bigpit
Blaenavon Community Museum: 01495 790991, www.fb.comblaenavonmuseum
Blaenavon World Heritage Centre: 01495 742333, www. visitblaenavon.co.uk
Fourteen Locks Canal Centre: 01633 892167, www.fourteenlocks.mbact.org.uk
Goytre Wharf: 01873 880899, www.goytrewharf.com
Newport Museum: 01633 656656, www.newport.gov.uk
Newport Transporter Bridge: 01633 250322, www.visitnewport.wales
Pontypool Museum: 01495 752036, www.torfaenmuseum.org.uk
Risca Industrial History Museum: 01633 264819, www.riscamuseum.org.uk
The Tunnel Centre, Sudbrook: 01291 420530
Tredegar Local History Museum: 01495 357869, www.tredegarmuseum.co.uk
The Works, Ebbw Vale: www.evwat.co.uk

Acknowledgements

Special thanks are due to my friend the late Michael Blackmore who had a remarkable talent for recreating the past in his detailed pen and ink drawings and watercolour paintings. Those in this book were specially commissioned for inclusion in some of my previous publications. Most of the present-day colour pictures were taken by myself over many years. Some were also taken by my wife, Anne Marie, who accompanied me on many of my research trips and suggested various improvement to my draft manuscript.